Essentials of Indian Statecraft

The present work attempts to place before modern readers, a streamlined version of the greatest book on statecraft written in India, Before the Christian Era, by Kautilya, the most noted and feared minister to Chandragupta Maurya, the grandfather of Asoka and acknowledged as a consummate statesman of Hindu India. The book, *Arthasastra,* discovered by Dr Shama Sastry in 1904 in Mysore, can be said to represent the pinnacle of Indian intellectual achievement in the fields of politics and public administration. Several academic theses have been woven around this *magnum opus.*

The present author has given selected portions of this great work in the present book, which could be said to hold the interest of the modern reader. He has covered fields like Administration, Economic Organisation and the Services,Interstate Relations and Diplomacy and the States in Crisis, as the topics for the present version of Kautilya's *Arthasastra.* Those who read will observe how modern some of Kautilya's thought-streams appear, considering that the original author was a contemporary of Aristotle and a practical statesman who engineered, single-handed, a *coup d'état* which overthrew the Magadha Empire and set up the Mauryan Dynasty which held sway over northern India for more than three centuries.

The interpretative introduction highlights some of the thoughts of Kautilya which deserve special attention at the hands of contemporary readers.

The author was educated at the University of Mysore and the London School of Economics. He was teaching Economics at the Banaras Hindu University and was for some time Head of the Department of Economics. He was also the Head of the Department of Economics at the Birla Arts College, Pilani, for a short while. He joined the Indian Administrative Service Staff College, Simla, as Professor of Economics in 1957 and was also appointed as Professor of Economics at the National Academy of Administration, Mussoorie, which was founded by the Government of India, in 1959. His published works include *The Economic Problem of India; Economic Stabilisation of Indian Agriculture; Full Employment for India; Rebuilding India; Economic Analysis of the Draft Plan;* and articles in the leading journals in economics and commerce in the country.

ESSENTIALS OF INDIAN STATECRAFT

Kautilya's Arthasastra for Contemporary Readers

T. N. RAMASWAMY

Professor of Economics
National Academy of Administration
Mussoorie, India

Munshiram Manoharlal
Publishers Pvt Ltd

ISBN 978-81-215-0655-7
Reprinted 1994, 2007, **2016**
First published 1962

PRINTED IN INDIA
Published by Vikram Jain *for*
Munshiram Manoharlal Publishers Pvt. Ltd.
PO Box 5715, 54 Rani Jhansi Road, New Delhi 110 055, INDIA

www.mrmlbooks.com

To
G. D. BIRLA
Pradeepah Sarva Vidyanam
Kautilya

PREFACE

THREE outstanding contributions were made by Ancient Indian writers to the field of the social sciences: *Dharma Sastra* or the Science of Legal Relations by Manu; *Arthasastra*, or the Science of Political and Economic Relations, by Kautilya and *Kamasastra*, the Science of Individual and Social Relations, by Vatsyayana. There may be greater books and writers on specific areas of these fields, both Indian and foreign, but the supremacy of the three thinkers over the general fields indicated has remained unchallenged to this day. No apology need, therefore, be offered for presenting Kautilya's *Arthasastra* as the "Essentials of Indian Statecraft" in the following pages.

Four major sections of *Arthasastra* are selected and presented here in view of the wider interest and appeal which they can be expected to command. Book One: General Background; Book Two: Administration, Economic Organisation and the Services; Book Seven; Inter State Relations and Diplomacy and Book Eight: States in crisis. Sections on civil and criminal law, elements of sovereignty, war strategy, operations connected with defensive and offensive, magical and diplomatic warfare have been excluded as having special environmental and historical interest and value.

My interest in the *Arthasastra* was aroused by a study of the late Dr Shama Sastry's interesting and pioneer rendering of the book; while my real appreciation of the true depth of Kautilyan thinking had to wait till I studied Professor Kangle's edition of the original text of the *Arthasastra* issued by the University of Bombay recently. To these two Kautilyan scholars, as well as to writers on specific aspects of Kautilyan contributions, I am specially indebted. I can specifically mention scholars like Professor Radhakumud Mukerji, Professor K.V. Rangaswami Iyengar, Mr K. P. Jayaswal and Professor Ghoshal.

I cannot proceed with this preface without expressing my deep sense of gratitude to Dr S. Radhakrishnan who has always been encouraging me in my literary endeavours. My gratitude is

equally heavy to Mr A. N. Jha of the Indian Civil Service,
Director of the National Academy of Administration for the kind
interest he has taken in my work since I started writing it and
for going through portions of it and offering valuable suggestions
for its improvement. Himself a profound scholar in Sanskrit
and former Vice-Chancellor of the Sanskrit University at
Banaras, his interest in my work was of inestimable value to me.
Dr Baij Nath Puri, Professor of Ancient Indian History at the
Academy has encouraged me further with his appreciative
interest in the work and with suggestions for making it accurate
in its settings. Yet the final responsibility for what is written
is mine so far as the defects of the work are concerned.

In preparing this work for the general reader, certain delicate
adjustments had to be made. The main section is faithful to
the original text of Kautilya's *Arthasastra*, as far as translation
into English would allow it. In the section on Inter-State
Relations, the word "King" has been translated as "State"—
a change which Kautilya himself would not have objected
to, as he himself considers both to be effectively synonymous—
in order to bring home the full significance of the Kautilyan
stand in the field to the modern reader. Since I have minimised
the use of Sanskrit in the translated sections, I had to annotate
the special interpretative Introduction, which I have appended
to the book, with key extracts from Kautilya's *Arthasastra*. I
am sure that these extracts would help those who are interested
in voyaging deeper into Kautilyan thought, as well as students
of the subject.

I must express my sincere feelings of obligation to Mr S. A. T.
Narayanan, the Administrative Officer of the Academy for the
help he so kindly extended to me in preparing the manuscript.

<div align="right">T. N. RAMASWAMY</div>

National Academy of Administration,
Mussoorie,
9 August, 1962

CONTENTS

BOOK ONE

DISCIPLINE AND ENVIRONMENT

BOOK TWO

ADMINISTRATION

BOOK THREE

INTER-STATE POLICY AND ADMINISTRATION

BOOK FOUR

STATE IN CRISIS

INTRODUCTION

"ESSENTIALS OF INDIAN STATECRAFT" attempts to present an abridged and selected version of the greatest book written in India on statecraft twenty-three centuries ago : Kautilya's Arthasastra. Though India had a distinguished lineage of statesmen, administrators, jurists and political philosophers, and the political wisdom of the country was found reflected over the entire field of Indian ecclesiastical and secular literature, from time to time, in pithy aphorisms, the science and art of statecraft was systematically presented only by Kautilya in his. *magnum opus*. Kautilya can be said to dominate the entire field of·Indian statecraft, as Samkara dominated the much more crowded field of Indian philosophy.

The severe individuality of a work like Arthasastra, written three centuries before Christ, makes the task of abridgement and selection especially delicate. The work is heavily worded with environmental specialities. One has to carefully feel his way through many conceptual and institutional impediments before reaching the core of Kautilyan thought which can be said to hold the interest of the modern reader and student of statecraft. Such an intellectual safari involves not only sifting of sections which contain thought-streams of lasting value and wider appeal, but inevitable scissoring of portions dealing with archaic topics like planning of elephant forests, training of elephants in peace and for war, construction and mapping of ancient forts, magical and medicinal weapons of defence and destruction and ancient Indian culinary concoctions—all of which had special environmental value for the survival and conservation of an ancient state in a pre-christian secular climate.

The Arthasastra is truly an anthology of political wisdom and theory and art of statecraft, scattered in pre-Kautilyan writings, streamlined and reinterpreted by Kautilya in his attempt to construct a separate and distinct science of statecraft. It abounds in aphorisms, a special and elusive vehicle for the conveyance of concepts of enduring significance intermingled

1

with environmental integuments, which offer serious challenge
to commentators on the original text who, unless they possess
the background and the vision to correctly evaluate the aphorisms
contained in the original work, may miss the full significance of
the thought-streams released by the author. To avoid such
a fate overtaking his Arthasastra, Kautilya himself wrote a
commentary on his *magnum opus* which further complicates the
task of reinterpreting the field of statecraft as presented in his
work and segregating the sections which would really interest
a wider range of readers in the twentieth century. It is here
that an interpretative introduction which attempts to explain
the especial environment in which Kautilya composed and
propagated his work on statecraft and to highlight the thought-
streams which he released, is rendered inescapable.

II

Kautilya, the author of Arthasastra, has two other names which
are equally celebrated : Vishnugupta and Chanakya. As in
the case of all ancient Indian personalities, a heavy historical
mist hangs around Kautilya, created mostly by doubting thomases
and academic wranglers. Assuming his very existence as
beyond dispute, there is little doubt that Kautilya, like Cardinal
Richelieu of France, was the most feared personage of his time.
He performed the unparallelled feat of undermining the legendary
might of the Nanda dynasty and setting up Chandragupta, the
grandfather of Asoka the Great, on the imperial throne of
Magadha. Dhana Nanda, the emperor known for his legendary
treasure in gold and precious stones, had to face the fate of
Darius of Persia before Alexander the Great. Only Dhana
Nanda's life was spared, along with those of his two queens,
who were allowed to leave the metropolis of Pataliputra on their
imperial chariot with their personal possessions.

In spite of the powerful spotlight which his victory over the
Nanda emperors focussed on him, Kautilya continued to be a
political enigma in the best brahminical traditions of ancient
India. The spectacular *coup d'état* which overthrew the Nanda
Imperial Dynasty is referred to by Kautilya in a modest couplet

at the end of his Arthasastra.[1] Legend has it that Kautilya, after installing Chandragupta on the Magadha throne, himself lived in the cremation ground on the outskirts of the imperial city of Pataliputra, in a modest thatched hut pursuing the injuncted brahminical profession of training pupils. He contented himself by playing the intermittent, yet powerful, role of an occasional super-adviser to Emperor Chandragupta, having secured for him the services of Rakshasa, the popular adviser to the Nanda dynasty, as a regular minister. His paradoxical life, imbued with fanatical fervour in fighting the Nandas, single-minded devotion in setting up the Mauryan dynasty, aversion to power or pelf in leading a life of renunciation in a mud hut in the cremation grounds, created a wealth of legend and lore around Kautilya's life, scattered in ancient Hindu, Jain and Buddhist literatures.

Contemporarily, Kautilya's *coup d'état* overshadowed his authorship of Arthasastra, which had to pass through the ancient grill of oral propagation. Why his *magnum opus* passed into an unrelieved oblivion of twenty-three centuries is an inexplicable mystery which is as deep as that of the spate of different palmleaf manuscripts of the Arthasastra which followed the discovery of the first manuscript by Dr R. Shama Sastry of Mysore in 1904. After the original manuscript was discovered by Dr Shama Sastry, discoveries of other versions of Arthasastra followed quickly. Professor Kangle mentions as many as seven different manuscripts, of which only one is a northern version, the incomplete manuscript at Jain Bhandar at Patan in North Gujerat.[2] Kautilya was a brahmin adventurer who reached the ancient metropolis of Pataliputra after completing his education at the ecclesiastical university of Taxila. He took service under the Nanda emperors, at Pataliputra, as controller of a charitable trust endowed by them. Kautilya must have been physically uncouth, like Socrates, which explains his extreme sensitiveness to insult which pitched him against the Nanda emperors, against whom he plotted and whom he overthrew and set up Chandragupta Maurya on the throne. This much outline of Kautilya's life can be gleaned incontrovertially from various references to him in Vishnupurana, Kamandaka's

Nitisara and the Nitivakyamrita of Somadeva Suri, a Jain author.

The impenetrable fog surrounding the life of Kautilya has been responsible for his age being swung over a span of ten centuries by contesting scholars—from third century B.C. to seventh century A.D. There is no doubt that Kautilya lived in a stormy environment. The northern part of the country was split among several principalities including the Greek pockets left by the Alexandrian invasion into the Indus Valley and the eighteen republics mentioned by Panini. They all represented a bewildering diversity of political and social existence, which necessitated the forging of a delicately balanced system of politico-economic relations among them. This contemporary environment highlighted strategic and diplomatic devices to face the challenge of internal security and external contacts. Both wisdom and weapon were strained to imponderable dimensions.

Kautilya's task as a super-adviser to the Mauryan dynasty was two-fold : firstly, he had to preserve and propagate the newly-established authority of the Mauryans, caught in the crosscurrents of conflicting loyalties, which his *coup d'état* had generated; secondly, he had to dissolve the powerful pockets of emotional disintegration which foreign political and emotional islands, left behind by Alexander, had set up in the western corners of the country. Within the Mauryan sphere of influence, the task was not only of consolidation but also of expansion towards the east and the south east of the country. Security had to be ensured, new loyalties tested, old loyalties besieged and dissolved, new territories conquered, diversity of administrative techniques conceived and foreign relations carefully manoeuvred. Some of these programmes would outspan the life of an individual adviser or ruler. A science had to be constructed which would sharpen both the wisdom and the weapon to meet the challenge of the environment and the task.[3] Such wisdom and weapon were found scattered through the various epics, historical narratives, the legends and the lore. Kautilya had to collect these instruments of policy from different sources and consolidate a science for world conquest and consolidation.[4]

Obviously, the Arthasastra was not addressed only to the Mauryan kings as Dandi pompously and pedantically claims seven centuries after Kautilya.[5] In fact, the object of propagating the science of statecraft was much wider and nobler as is clearly indicated by the author in the last three stanzas of the concluding chapter of the book : for integration of the art of governance of the two worlds : the present and the future.[6]

With an eminence so arduously earned, Kautilya was induced to accept chosen pupils anxious to learn the art of statecraft in his unpretentious and austere academy. The most celebrated among the pupils so trained by him was Kamandaka, the author of Nitisara, who refers to Kautilya in glowing terms.[7] The science thus orally propagated to an esoteric circle of ardent scholars, carefully chosen by Kautilya himself, must have migrated, with the passage of time, to the south-western tip of the subcontinent to lie dormant till 1904, when it first made its appearance in Mysore. Kautilya himself was apprehensive of the meddling hands of the commentators : having seen the havoc wrought by commentators in many sciences, Vishnugupta himself wrote the text as well as its commentary.[8] Even this precaution was no guarantee against interpolations and marauding of the science. The text is hard and capable of several interpretative twists, as those who have dabbled in it are aware. Any careful study of the science, as presented by Kautilya, leaves no doubt of the trans-temporal perspective of the author, which alone is of lasting value to students of statecraft through time.

It is this trans-temporal perspective that invests the Arthasastra of Kautilya with thought-strands which transcend temporal and environmental limitations and preserve a refreshingly modern pragmatic pigmentation. This slant gave Kautilya's presentation of statecraft an enigmatic tinge, which must have irritated several post-Kautilyan authors like Bana and Dandi, who did not hesitate to expose the work to stinging satirical attacks. The Arthasastra must have fallen into the hands of unscrupulous pretenders who would extract support for their misdeeds from Kautilyan precepts on statecraft. If Dandi, the poet, holds up Arthasastra for the amusement of court ladies in his work Dasakumaracharita and Bana, the celebrated

author of Kadambari, launches a stinging attack on the work, the fault was not of the Author of the work, but of the pretenders who caught hold of it and misinterpreted the contents to suit their dubious manoeuvres. We have already seen how Kautilya himself issued a warning about the commentators. This may partially explain the undeserved anonymity suffered by the work for centuries and its migration southwards in the sub-continent for survival.

<center>III</center>

Against such a background, it was no easy task to fit the Artha-sastra into the general cultural framework of the country. Indian culture is essentially the product of the forest, the farm and the fort, in the order mentioned. The vedas, the epics, the puranas, sciences and arts of music—all were created in the sylvan environment of the forests. Our epic heroes spent a good deal of their lives in the forest. The farm, as the source of livelihood for the common man, produced pragmatic farm sense and lilting folklore and music. The fort produced arts and crafts and the masterpieces of classical literature. Yet, the Indian heart had a special affection for the wild charm of the forest, as distinct from the artificial life in the forts of the country. It is to this last category, that the Arthasastra belonged. The appeal, therefore, of the science was special, confined to the upper crust of the urban population, and it could only be rendered enduring by rehabilitating it with the essence of Indian culture.

In a special sense, therefore, the Arthasastra of Kautilya can be said to belong to the most modern and singular epoch of the manifestation of the Indian mind. The Indian mind had con-ceived of four distinct epochs of cultural synthesis, representing the four sides of the ancient dice: the Krita or Satya where the four instruments of existence: Dharma, Artha, Kama and Moksha representing the Law, Resources, Relations or Desire and Deliverance were in harmonic balance. In the Treta, Resource, Desire and Deliverance had over-shadowed the law. In the Dwapara, Resource and Desire were highlighted and in the Kali, Resource alone dominated the balance of existence.

These four epochs can be symbolised as the quadricyclical, the tricyclical, the duocyclical and the monocyclical epochs —the epoch, relevant for our study, being the monocyclical, where overwhelming emphasis on secular resources has driven the other three instruments of existence out of balance with one another, life here becoming more significant than life hereafter.

The monocyclical epoch has been variously characterised by different writers on Indian culture. The decay of cosmic conscience, conquests by foreigners, extinction of sacrifical fervour, tribulations of the saintly, verbal exuberance, multiplication of pseudo-sciences, elevation of forms and suppression of spirit, steepening of sheer gastronomical perspectives, shallowness of learning and wisdom, exhaustion of sincerity and true friendship, denudation of the earth, evaporation of essences in herbs, elevation of the undeserving, infidelty of wives, baseness and treachery of leaders and kings, crookedness of the intellectuals, insincerity of the offspring, distress of the just and the opulence of the wicked—all these are portrayed picturesquely as the distinguishing traits of the monocyclical epoch. The Arthasastra of Kautilya falls in this epoch.

Kautilya attempts to establish that the socio-cultural erosion affecting the monocyclical epoch is symbolic of the general degeneration of resources.[9] That should invest a special significance to the science of resources, as the foundation of balanced survival of law and amity. If disintegration of the management of resources has been responsible for socio-cultural decomposition of the monocyclical epoch, the value of a proper study of the science of management of resources cannot be overlooked. It must also be realised that one wheel does not move the chariot of progress.[10] Integration of resources is essential for the attainment of popular well-being, and social peace.[11] Social peace indicates an intergrated social order. An integrated social order can be said to be founded on a progressive balance of the professions and the construction of balanced perspectives on problems of living. This can come as the consequences of educative discipline for the people.[12] The central instrument for the propagation of all pragmatic knowledge is a balanced metaphysical perspective.[13] Of pragmatic sciences, the most

important are: the science of law and order, the science of management of resources and the science of human relations. The task of creation and sustenance of an integrated social order, so essential for peaceful progress of human societies, can be said to pervade these three vital fields of human knowledge compressed into knowledge of Dharma or Law and legal relations, knowledge of Artha or resources and economic relations and knowledge of Kama or inter-individual and inter-social cultural relations. Without these, society would simply drift into dissolution.[14] That these vital branches of human knowledge are space-bound and time-bound, is easily recognised. Legal concepts and institutions, economic concepts and institutions, social concepts and institutions prescribe, for every stage of development, what is legal and illegal, what is economic and uneconomic, what is individual and social peace and conflict.[15] Propagation of these sciences, therefore, is vital for balanced survival of societies and preserves them, through conditions of crisis and progress, in a state of enlightened balance with their environment, by investing them with stabilised socio-cultural perspectives.[16]

Though the value of education in forging balanced perspectives is stressed, due emphasis is still on traditional education, rather than on reconstruction of education to mould new and daring perspectives for the leaders of society. Here Kautilya can be said to follow the veneration of tradition which Burke valued, rather than the stand of J. S. Mill who argued for reconstruction of society on new foundations. This is explained by the delicacies of the task that Kautilya had to face, a delicacy which is best explained in the language of Machivelli: "When dominions which are added to an ancient state are . . . of the same country and language . . . he who has annexed them if he wishes to hold them, has only to bear in mind two considerations: the one, that the family of the former lord is extinguished, the other that neither their laws nor their taxes are altered."[17] Kautilya had to face these two issues and also had to get recognition for his Arthasastra, which he describes as an anthology of politico-social wisdom scattered over the pages of ancient writings.

Since the personality of the architects of state policy is of

vital significance in giving adequate sanction to any line of policy promulgated, education must be conceived as an instrument utilised to give dignity to the personality of policy makers. The appeal here is not to any *coup* which would dramatically reconstruct the social order, or the cultural pattern, but to a peaceful consolidation of the state. Statecraft cannot, therefore, rebel against its social and cultural environment and yet survive. Performance of one's duty is essential for the sustenance of an integrated social order and cultural pattern.[18]

It, therefore, becomes inescapable to preserve the social order and the cultural frame of any society from the invasion of disintegrating influences.[19] Integrity of social institutions is of paramount value for ordered social progress. Education as well as administration should not violate that traditional integrity of the social system, if balanced progress is the aim of state policy. Government must, therefore, frame policies which foster such patterns of progress.[20] And administration should strengthen the weak against invasion from the strong. Therefore, all education hinges on authority.[21]

Propagation of education can only be ensured under social tranquillity and presupposes the existence of authority, and obedience on the part of society to established authority. Education, therefore, should be imparted to foster obedience to authority which is so vital for social peace. Education can benefit only those who have certain propensities for scholastic discipline: listening, grasping, retaining, discriminating, inferring and concentrating and not others. The concept of selective education is highlighted here as against democratic or mass education. Kautilya here evidently stresses education for social leadership as being of paramount significance for social tranquillity. What is attempted to be set up, through state policy, is an aristocracy of education more like a modern brain-trust and the training of policy makers in all cultural aspects is specially emphasised. The potency of education is reflected in infusing balance of perspective to the educated.[22] Hence, education must be imparted by specialists in the different fields of knowledge. This concept of education deserves to be reviewed in the light of the progressive processes of diffusion of social and cultural

leadership and the forging of new instruments for the propagation of knowledge, with the passage of time.

The concept of education, projected above, was perhaps necessary to eliminate multiplication of points of socio-cultural friction in an ancient society among the three major stems of socio-cultural influence : the ecclesiastical, the professional and the governmental, which might weaken the bastion of authority in the state. Ecclesiastical harmony is necessary to preserve popular loyalty to established authority. Professional harmony is essential to preserve society from forces of recession and secular distress which disintegrate loyalty. Governmental integrity is essential for maintenance of social peace and for enriching the streams of socio-cultural advance.[23]

It is with a view to strengthen balanced perspective that the study of sacred lore, history, didactic stories, administrative sciences, sciences of resources-management—are all prescribed for rulers and leaders of men. A study of these branches of knowledge would invest a proper appreciation of environmental forces operating in any society. Education must assist the educated to shatter the integuments of parochial attitudes, and subdue the personal for the social. This calls for self-control.[24] Self-control implies control over one's personal weaknesses, especially over desire, anger, greed, arrogance, pride and exuberance.[25] Discipline, with regard to any of the sensory fields indicated, can only come from the discipline awarded by a knowledge of the pitfalls into which these sensory temptations may drop any person. If these weaknesses lead smaller men into fields of crime, they plunge rulers and social leaders into state and social disasters. It is, in dealing with these spheres, that a vast field of espionage is opened out. History has recorded the ruin and disaster of vast empires as a result of the entanglement of their emperors and leaders in the tantalising manifestations of the five senses of sound, touch, beauty, taste and smell.[26] Mere conquest over sensory temptations would not make one a great ruler or leader. He must acquire traditional and secular wisdom from elders; he must be posted with latest information through newsgatherers; he must secure welfare of all by energetic action, protect social integrity

by ordered action, obtain obedience by education, ensure
social welfare by conservation and agglomeration of resources,
and secure livelihood for all with good intentions. These
functions cannot be performed single handed : they must be
planned and executed by powerful body of counsellors.[27]

Thus, according to Kautilya, statecraft is the sustaining
power for the other branches of knowledge and, consequently,
the instrument for the preservation and propagation of all
forms of knowledge which contribute to social tranquillity and
cultural advancement. It is the instrument for the ennoblement
of the individual ruler as well as for the preservation of
authority, so vital for the very existence of social relations and
the observance of conduct, which should contribute to the
welfare of all the different classes of society. Without Artha or
proper knowledge of administration of resources, no culture can
survive.[28] The administration of resources must be planned
so as not to conflict with contemporary concepts of law and
general relations. When administration is tinged with impious
desire, it provokes those who are administered; when diplomacy
is vitiated by it, it creates enemies abroad.[29] Both these are
the paths of the condemned.[30] Resource, right and relations
are the three instruments of well-being; resourcelessness, wrong
and distress are the three instruments of disaster.[31] It is in
attempting to prefer resource, right and relations that Artha-
sastra gets integrated and set into the cultural framework, which
sanctifies the three major springs of pragmatic knowledge :
the Dharmasastra of Manu, the Arthasastra of Kautilya and the
Kamasastra of Vatsyayana as indicated by the author of Pancha-
tantra.[32]

IV

Since administration is a coordinated endeavour, of the cream
of society, to create conditions for socio-cultural balance and
advancement, policy formulation must be conceived as emanat-
ing from a group of advisers and ministers, who are to be
especially selected for this vital function. Several considerations
should govern the selection of advisers and ministers: homo-

geneity in age and outlook, trustworthiness, devotion to duty, ancestry and ancestral eminence, training in pragmatic sciences, high sense of loyalty and high capacity for work. These should be selected as administrators, not as advisers. The best talent should be netted for administration, either as advisers or as administrators. The qualities to be considered are: nativity, ancestry, influence, dexterity in arts, clear prevision, wisdom, endurance, perseverance in work, eloquence, assimilation, enthusiasm, fortitude, cleanliness, friendliness, high loyalty, character, strength, health, balance and amiability. In this context, we may compare the qualities enumerated by Nicolson for ambassadors: "In an age when personality is one of the decisive factors in politics, the character and intelligence of an ambassador are of vital significance The policy of a cabinet can only be rightly executed if they possess as their representatives on the spot a man of experience, integrity, and intelligence; a man of resource, good temper and courage; a man, above all, who is not swayed by emotion or prejudice, who is profoundly modest in all his dealings, who is guided only by a sense of public duty, and who understands the perils of cleverness and the virtues of reason, moderation, discretion, patience and tact."[33] If these are the qualities demanded of ambassadors, the qualities demanded of administrators and advisers must be much more rigorous and exacting. There is little exaggeration if Kautilya, in enumerating the imposing qualities of administrators, says that if men have only half of these qualities, they are mediocre advisers.[34] The difficulty of devising techniques to evaluate these qualities in persons is acknowledged. The Chinese devised an examination system, while Kautilya would diffuse the range of test to as wide a circle of experts and associates as is practically possible. Nativity and ancestry were to be ascertained by reference to intimates, known; dextrity and scientific prevision by experts in the field and by associates; so also eloquence, brilliance in reporting, presence of mind, endurance. Sociability, friendliness and fidelity from colleagues. So also character, strength, health, balance of attitude and stability, by observation. Friendliness and amity should also be examined by observation. Such a process of

evaluation is time-consuming and strains any technique of coordination of relative valuations, made by different categories of examiners. Thus personal perception, evaluation by others and inferential evaluation are three modes of royal estimation.[35]

V

Planning of vital intelligence is essential for the survival of consolidated authority, where loyalties have to be constantly evaluated and opinion has to be constantly checked. Such planning becomes more vital in an age where news service is non-existent. Even where journalistic service is widely and efficiently organised, intelligence planning becomes an essential part of administrative equipment only to differentiate the personal from the institutional, in journalistic approach to any problem of policy or of administration. Vigilance in administration must be protected by concealed tests of loyalty and constant screening of administrative personnel.[36] These tests are necessary to the grant of suitable assignments to administrative personnel. Those who pass specific tests are to be given specific assignments. Those who pass all the tests of loyalty and integrity should be established as ministers.[37] In a monarchical set-up, as in a democracy, there are certain dangers which ought to be carefully warded off. Royal irresponsibility may be caused by lack of information on vital issues: this arises from "ignorance of ascertainable facts."[38] The second danger arises from certain brands of knowledge arising from faulty evaluation of observed facts and trends. The third danger arises from inferential errors and delays. The fourth danger arises from imprecision arising from faulty organisation of intelligence services. These dangers have to be minimised by multiplicity of intelligence sources. The rulers will have to be like Indra who had a thousand eyes—a thousand sources of information and counsel.[39]

Such an approach to problems of intelligence naturally would underline the existence of an intricate and widely diffused espionage network. Espionage must pervade all classes and categories of citizens: pseudo-student, ascetic, householder, merchant, saint, and spies classified into colleague, firebrand,

poisoner and mendicant woman. Spies can be further classified into spies stationary and spies peripatetic. All these spies must be suitably rewarded for their meritorious services and should carry their observations on administrators with loyalty and devotion to the ruler. Peripatetic spies should be drawn from state orphans especially trained in occult sciences, sciences of social relations and the arts of casting influence on people. These should operate over a wide area, collecting information about the government personnel, function as the vigilance and anticorruption squad and also operate in unearthing foreign spies operating in the state.

Apart from coverage of government personnel, the espionage service should cover the general populace of the state as well.[40] Thus espionage must cover three vital fields of state life: collection of news; testing of loyalties and handling of propaganda. Certain modern parallels to such strategy, in the use of espionage personnel, can be drawn in relation to the press. We learn that "Cavour in Italy and Bismark in Germany employed the Press for the purposes of secret rather than of open diplomacy, and Bismark himself was not above fabricating articles and letters which served the uses of his policy".[41] In Italy, Germany, Spain and the USSR, "the controlled Press is used as a vehicle of propaganda." In democracies, the Press is used for purveying information and instruction to the public. Even where "free press" exists, it is doubtful if the press achieves anything like true freedom of the press, specially when certain financial and political interests get hold of the journalistic sector. It is no wonder if it is observed that "a satisfactory adjustment between the needs and rights of a popular Press and the requirements of discretion has yet to be found."[42]

The object of espionage is to operate as contact surveys for formulation of suitable policies, which widen the base of loyalty to established authority. Contentment should be as widely broadcast as possible through the discriminate and discreet use of rewards, conciliation and chastisement. Those who are chronically dissatisfied should be appeased by the accredited four forms of strategy : conciliation, gift, alienation and sanction.[43]

The positive functions of propaganda should be to reduce

the sweep of discontent or distress and to prevent the exploitation of the state subjects by interests hostile to established authority, whether the hostile interests are indigenous or foreign. The former will have to be won over by state policy and the latter by diplomatic offensive. The most important consideration should be the neutralisation of forces attempting to subvert the loyalty of the people to established authority.[44] This implies rooting out of the angry, greedy, alarmed and ambitious groups of dissentients in the state, who afford fertile fields for enemy propaganda and machination.[45] Consolidation of authority in one's state also calls for direction of propaganda in contiguous states towards enlisting the active support of similarly disposed groups.[46] The major weapon in all these strategies is secret or concealed propaganda.[47] It is hardly necessary to add that Kautilya was specially aware of the full significance of what Canning recognised in 1826 as "the fatal artillery of popular excitaton," both within the state and abroad. While modern propaganda has played a vital role by providing "a formidable weapon of popular excitation" in times of war, among belligerent states, it has played a spectacular part in cultural war in Hitler's technique of softening resistance, its two powerful weapons being: fanaticism and occasional hysteria directed towards the masses. This is distinct from selective propaganda aimed at selected social groups advocated by Kautilya. Propaganda can operate as the Frankenstein monster and attempt to destroy its own creator, and must be used with extraordinary dexterity, as demonstrated by Italian propaganda through wireless by Mussolini and the Nazi tirade over the Sudeten Germans, which boomeranged with devasting consequences. The money spent by some of the modern governments on propaganda reaches staggering figures, demonstrating the vital value attached to foreign propaganda by modern states.

VI

Having consolidated loyalty both at home and abroad to one's authority, administrative organisation should be attempted.

Deliberation is the foundation of all administration.[48] The life of deliberation is secrecy which must envelop all council proceedings. They should be wrapped in such deep secrecy that even birds cannot see them.[49] Top secrets have often been shattered by even dumb animals like parrots, dogs and other varieties of birds.[50] This secrecy must be preserved at the cost of lives, since divulgence of any measure prematurely may lead not only to loss of lives but to state disasters. This divulgence is indicated by changes in countenances and conduct of the culprits, and, the basic attributes leading to disintegration of secrets, spring from personal weaknesses of the counsellors like nonchalance, alchoholism, sleep-talking and infatuation of women.[51] It is very essential for state security to guard counselling against these self-destructive foibles.[52]

The number of participants in state deliberations should be determined by the demands of time, place and nature of work to be transacted.[53] So that, unnecessary disputes, confusion of complicated issues, divulgence of vital secrets and domination of proceedings by a single minister or adviser are all avoided. The ruler should take counsel both individually or collectively from his ministers and advisers.[54] The strength of the supreme state council cannot be determined without reference to state requirements and administrative efficiency.[55] It may vary from twelve members, according to Manu, to a thousand members as with God Indra.[56] In emergencies, deliberations may be more broadbased.[57] This may imply the cooption of experts in addition to the normal ministerial and deliberative bodies in times of grave national emergencies, who are also bound over for maintaining secrecy of deliberations and sound the majority opinion on vital issues.[58]

VII

Kautilya attaches great importance to the selection of diplomatic personnel which, he insists, must be done with the same care with which senior consultative and administrative personnel are selected. An ambassador should possess the same high qualities as a royal counsellor.[59] A senior administrator must

be assigned the post of a minor diplomat.[60] Lord Krishna himself undertook diplomacy with the Kauravas on behalf of the Pandavas in Mahabharata and God Hanuman with Ravana on behalf of Rama in Ramayana, the two great epics of our country. These diplomats must be properly equipped before being sent abroad.[61] They must have proper conveyance, travelling equipment, men and personal belongings for their dignity and status. Nicolson, in his chapter on "The Ideal Diplomatist", enlists seven qualities of a diplomat: "A diplomatist may be truthful, accurate, calm, patient and good tempered, but he is not an ideal diplomatist unless he be also modest...the seventh great virtue of the ideal diplomatist is the virtue of loyalty."[62] The diplomatic disasters of Napoleon at Dresden in 1813 with Matternich, of Sir Charles Euan Smith with the Sultan of Morocco, of Count Tattenbach at Algeciras and of Herr Stinnes at Spa indicate the need of the extreme care that should be bestowed on the selection of national representatives abroad, elaborated by Kautilya many centuries ago in his Arthasastra.

Ambassadors are the mouth pieces of nations and rulers[63] and their duties are onerous and delicate, including conveyance of missions, issue of ultimata, forming of alliances, planning of propaganda, breach of alliances, organising espionage, smuggling of friends and treasure, collection of espionage intelligence, exhibition of prowess, extradition and corroboration, to mention a few of the major diplomatic duties,[64] which can put enormous strain on the cream of any nation's intelligentsia.

VIII

We now come to discuss an institution which held the historical canvas for several centuries in our country and abroad and which like, "boudoir diplomacy," made its exit in very recent times, specially after the second world war—the king and the royal family. Throughout history, the crowned head is a very vulnerable object, open to attack from all directions—the queens, the princes, conspirators, poisoners and pontiffs. Where the

state and the crown are synonymous, special precautions for the protection of both become inexorable. The cynic will take special delight in Kautilya's aphorisms on the subject. The king should protect the kingdom and himself from his wives, enemies, intimates and princes.[65] The chapter is ironically entitled protection of princes (Rajputra Rakshanam). Of the ancient writers, Bharadwaja emphasises the need to devise measures for the special protection of royal children who, like crabs, have the extraordinary filial knack of swallowing their male begetters.[66] The most notorious figure in our history, who fitted this description, was Aurangzeb who waged war not only on his father, but on his brothers and children as well. The only sovereign remedy for the situation is, according to Kautilya, enlightenment of the princes, properly planned from their birth to their adolescence.[67] A corrupt prince should be restrained and detained. A worthy prince should be made commander-in-chief and heir-apparent. If a king has an only prince, who is perverted, a grandson should be attempted either through him or through a princess. When the king is too old to beget a worthy prince, he should attempt to get one in his queen either by a relative or by a worthy neighbouring king: Kautilya sees no objection to permit a queen to have a prince from any of the royal relatives, in the interests of the tranquillity of the state : never should an unworthy and corrupt prince be allowed to wear the crown.[68] Except in grave state emergencies, succession by primogeniture is always venerated.[69] A Spartan selection indeed.

On the other side, filial affection and duty are stressed on the royal children—specially the princes, unless[70] such obedience endangers their lives, incites the people or generates state calamities. The right of a prince to rebel against the king is not denied to him. Reconciliation through the queen with the king should also be attempted. If a prince is abandoned by the king, he can be killed by secret spies or by poison, a typical Moghul custom of consigning dissident princes to the Gwalior fort for slow poisoning.[71] An unabandoned prince may be enticed by women and liquor in nocturnal revelry. If a king has many children, the unruly prince may be banished.[72]

IX

Centralisation of authority in the hands of the ruler would naturally create heavy pressure on his time. An energetic ruler will generate energetic servants. A lethargic ruler is consumed by his entourage as well as by his subjects. The same is the situation with dictators, as we have seen in the case of Hitler, Mussolini and Stalin. Therefore, a ruler must be energetic and vigorously plan his day,[73] so that work and worship are properly observed. He can earn short rests during the day and the night which are to be divided into eight equal sectors of ninety minutes' duration each. A vigorous and faithful observance of such rigid routine may expose the ruler to fits of uncontrolled hysteria and megalomania, as in the case of Hitler and Mussolini, as no ordinary nerve can long stand the strain of rigid routine, the time table projected may be varied to suit the personal convenience of individual rulers.[74] The most important consideration in the matter being a balanced approach on the part of the ruler to every problem submitted for his judgment and disposal.[75] He must bear in mind that his prosperity depends on state prosperity, or the prosperity of his subjects.[76] It is only by high pressure activity and through popular approbation that a ruler can conserve his resources by energetic living. Energy is the foundation of state conservation.[77]

Personal security of a ruler is vital for state security and with this consideration, the royal residence should be planned so that the residence may afford protection to the ruler against the machinations of power-hunters and accidental mortality caused by poisonous creatures, schemers and calamities. Detailed enumeration is given of all necessary paraphernalia to meet the normal and abnormal emergencies of large royal households; segregation of royal ladies is pleaded specially from the company of undesirable and scheming sections of the population. Espionage vigilance of a high order is advocated to secure the ruler's person and his family's tranquillity. Strict screening of all persons and commodities passing into and out of royal palaces is prescribed. Eternal and energetic vigilance

which covers the movements of every resident of the royal household makes the palace as rigorous as a prison in the enforcement of rules and regulations, which are very essential if the ruler's personal safety and the security of the royal family are to be properly planned.

Special personal security measures for protecting the person of the ruler are prescribed against poison either by professional poisoners or by court physicians. We learn of the peculiar custom of employing courtesans for attending the bathroom of the ruler. Court entertainers are forbidden to use lethal weapons and fire when performing before the ruler. Assassinations of heads of state by persons camouflaged in such public performances testify to the wisdom of such precautions. Even musical instruments are to be kept in the palace itself. The royal conveyances should be safeguarded against accidents; so also royal barges and boats. The ruler should hunt only in the royal forest, where security measures against hunting "accidents" are carefully screened. The ruler should inspect his army with full military dress as a security precaution. He should not attend any public festival or performance without the function being policed by his personal security staff. Even saints and ascetics should be interviewed in the presence of security guards, who are fully armed for emergencies.[78] Journeying through the highways, the routes taken by the royalty should be lined with security guards.

X

At this stage, Kautilya takes up the subject of planning of institutions and politico-economic functions within the state. Planning not only involves conservation of existing resources but initiation and development of new projects, all intended to strengthen the state and the exercise of authority.[79] Rural settlements as well as urban communities must not only be founded, strengthened and fortified, but general administrative structure conceived and conserved to help the maintenance and development of a strong and consolidated politico-economic framework, which can ensure the well-being and prosperity of

the people of the dominion. Excessive pressures of population must be avoided and wastage of land resources eliminated by new rural and urban settlements.[80] New settlements must be founded either by attracting foreign settlers or by exodus or local population from highly populated tracts.

Farming and professional populations should be encouraged to build up rural settlements. Rural planning, under Kautilya, would postulate that rural settlements should consist of families not less than a hundred in number and not more than five hundred—population groups between five hundred and two thousand for every village,[81] woven into an integrated pattern of settlements segregated by strategic zones, not exceeding a radius of about two miles among villages.[82] The focal strategic centre of eight hundred villages should be a major fortified town.[83] Every group of four hundred villages should have a medium-sized fort[84]; for every two hundred villages a minor urban unit[85] and a conservation centre[86] for every ten villages. These are not only defensive but also development institutions. Religious instructors and social educators should be settled on lands yielding sufficient produce for their sustenance. So too administrative personnel like controllers, accountants, city and fort officials, medical personnel and informants must be endowed with inalienable land in rural settlements. Tenants should be given life-interest in their holding and cultivators should be protected from royal and other confiscations of their land-interests. Every assistance should be accorded to cultivators in the form of grain, cattle and money as subsidies.[87]

All these measures should be with a view to conserve resources and mobilise fresh resources as will strengthen the exchequer and not deplete it.[88] An impoverished exchequer becomes a predatory menace to the population. Reimbursements and remissions should be appropriately timed to encourage new settlements and similar situations with parental benevolence.[89] Mining explorations, manufacturing enterprises, forest conservation projects, irrigation and communication schemes, cattle conservation endeavours and marketing facilities should all be carefully planned and developed.[90] For private developmental projects, arrangements for construction materials should be provided.

Free labour planning should be enforced for corporate developmental projects. State interest (royal ownership) of fisheries, vegetable gardens and reservoirs should be enforced.[91]

In the field of social security planning, slaves, servants, and indigent relatives must have their rights established.[92] Maintenance must be provided for orphans, senile persons, distressed and destitute populations and forsaken women and social children.[93] Religious and minors' property must be cared for by village elders.[94] When family welfare is neglected by earning members, they must be suitably punished; so also those who abandon family responsibility through conversion into asceticism or seduce women into ascetic types of living.[95]

Similarly, admission into villages is strictly regulated to cover only wandering hermits, local corporations and guilds. No village should have either sports or entertainment halls.[96] No actors, dancers, singers, orators, comedians and bards are to be permitted to exploit the villages,[97] and disturb the professions. Villagers should be allowed to exercise their professions without disturbance to their work from entertaining intruders,[98] and exhausting diversions. This did not mean that villages were injuncted to lead mirthless, puritanic existence, without any relief or refreshment from their daily toils. They were free to develop local entertainment agencies, construct temporary stages and organise communal religious and cultural festivals, without straining unduly local resources in manpower and materials. It is, in this manner, that local artistic talents found a milieu for flowering, and the country came to inherit a rich and multicoloured heritage of local festivals and cultural institutions like folk dances, harvest songs, open air rural dramas and religious lore, that we come across in the rural areas all over the country. It is evidently with a desire to provide an adequate framework for the diversification of local artistic and cultural talent, without straining the slender rural resources, that Kautilya advocates segregating rural areas from external predatory gangs of entertainers and cycophants, who may descend on rural areas during professional seasons, upsetting agricultural and professional routine and exhausting carefully husbanded rural resources in grain and gold.

XI

Land classification is a subject scattered in several separate sections of Arthasastra, though Kautilya deals with forest planning, specially of elephant forests and pastures in some detail. Thus pastures are to be planned in uncultivated land for the use of cattle. Sanctuaries for animate and inanimate beings and forests of *soma* plantations are to be planned.[99] Royal game sanctuaries, reserved for royal hunts, are also to be planned.[100] Public hunting parks should be planned on the borders of the state. Elephant forests for the propagation and conservation of elephants for state purposes should be carefully laid out.[101] Since elephants are valuable for the army operating as tanks and lofty royal conveyance, planning of elephant forests for preservation of elephant herds was carefully undertaken.[102] Famous elephant forests are indicated in an interpolated section of Arthasastra: ` Kalinga forest between Utkal and the Southern ocean, Anga forest in the Narmada region, the Ganga forest between Ganga and the Himalayas, the Dasarnaka forest of the Vindyan regions, the Saurashtra forest of the Avanti region, the Kalika forest of the Kurukshetra zone and finally the Panchanda forest (the Punjab forest) between river Sindhu and the Himalayas.[103]

Forts and fortifications come up next for consideration by Kautilya and are of purely contemporary interest, though the subject may have some conceptual attraction to a modern student. Fortifications are to be set up in the four corners of the state, depending upon the terrain and geographical features of the boundary. Four types of fortifications are mentioned: aqueous and mountain fortifications for populous regions; desert and forest fortifications for uninhabited areas.[104] Pillars, towers, ramparts, parapets, roads, pits, arsenals and turrets are all carefully dealt with, as well as buildings within the fort comprising of royal and administrative residences, water reservoirs, trading zones, sacrificial grounds and altars, quarters for different classes of professions and trades, stables, wells, stores. All this proves the care with which Kautilya deals with each topic of vital significance for the protection and development of the state.

XII

One of the most interesting as well as important sections of the Arthasastra is that which deals with administrative planning. Here, we deal with a highly circumscribed and centralised field of statecraft, where intensive and delicate planning would assume special significance. The centre of state activity is the royal capital from which authority radiates to the four corners of the dominion. Control on the main administrative life-lines would be necessary, if authority is to be exercised in the remotest nook of the state with undiminished vigour. Able men have to be selected for federal administrative positions; forceful techniques of administrative control devised to permeate authority in the most remote state corners to ensure loyalty and obedience of the population; quick execution planned to meet state emergencies like war or pestilence; provisions secured, stored and distributed so as to cause no alarm and scare among the populations, encased in fortified towns, in times of threat to economic life-lines of the forts by invading enemy forces; treasures and arms secured and conserved so as to meet emergencies of defence and attack. All these problems were both centralised and diffused over vast areas, cut off from each other by primitive modes of transport and communication, which caused heavy time-lags between administrative conception of measures and their execution over scattered areas. In a sense, administration had to move with far greater speed and efficiency in closing spatial and temporal gaps rendered inevitable by environmental handicaps, than it need do in a modern state, where speedy transport and communication have rendered such emergencies of less strategic import than in states twenty-five centuries earlier. Paradoxically, in pre-Christian era, the administrative structure had to be simpler and capable of manoeuvre at lightning speed and impact than is ever possible in a highly complicated, intricate and diffused administrative structure in a modern state, where quick and efficient transport and communication techniques obviate the need for such quick and efficient administrative manoeuvres, except in times of grave national emergencies like war and natural devastation. Multi-

plication of administrative personnel, complication of administrative techniques and diffusion of administrative procedure and responsibility have elevated the institution of red tapism in modern states, making administrative delays much more notorious than judicial delays. In fact, administrative perspectives in an ancient state can be said to resemble army perspectives in times of war and yield valuable parallels in conception an techniques to any state attempting planning in modern times. We might come across here the pattern of monocyclical planning for state conservation in its most vital field, as conceived and developed by Kautilya in his Arthasastra.

The first office to be considered is that of the royal housekeeper, a general factotum of multifarious state functions with wide powers over state construction activities. All state construction work is concentrated in him : exchequer construction, exchange house, state stores, state armoury and state prison.[105] Careful planning of his functions and the construction details he has to undertake are mapped out including dimensions and details of each type of building and pathway. Residences of administrative personnel are also indicated in great detail, along with residences for different professions, deities and shrines. He has also to control general stores built up over years to last for years and supervise replenishment of such stores. He should cut counterfeit coins.[106] He should organise collection of income with the help of trusted colleagues.[107] He is expected to have a complete knowledge of the royal budget for a hundred years.[108]

The next administrative office is that of the collector of revenues whose authority extends over forts, country-side, mines, bridges, forests, cattle settlements and trade routes in collection of state dues.[109] Each head of revenue is described in close detail as well as each item of expenditure. He should address himself to an increase of revenue over expenditure, a normal conception of balancing state budgets.[110] Accounts planning is considered contiguous to collection of revenue and budget balancing, having many departments or divisions dealing with cash, jewels and precious metals, factories, wage-bills, royal gifts and emoluments to state officers, income and gains of the royal

household, treaties and agreements made on behalf of the state and ultimata issued. In fact, these functions appear to be the functions covered normally by State Archives, State Banks, and Finance Departments of modern states. These functions are state-wide, and separate balance sheets are to be presented by every department and scrutinised by the ministers concerned, and officers suitably punished or rewarded.[111]

Exchequer is the foundation of all administration: therefore, it must be properly supervised.[112] Factors tending to strengthen the exchequer must be carefully protected and factors tending to deplete it, as carefully controlled. Abundance of activity, bonuses for high performance, conquest of thieves, retrenchment of superfluous staff, harvest wealth, trade prosperity, elimination of obstacles, depletion of tax-remissions, inflow of gold—strengthen the exchequer.[113] Factors which create attrition of the exchequer are: obstructive economy, investment, personal trading (with state funds), falsification of state accounts as, revenue losses, extravagance, conversion of wealth and misappropriation.[114] Kautilya goes on to mention forty methods of embezzlement of exchequer funds and prescribes graduated punishment for exchequer crimes by officials entrusted with the work of administering the treasury.

Those possessing advisory qualifications should be given assignments of directors of administrative departments.[115] Having appointed them, they should be kept under eternal vigilance to guard them against human frailties in administration.[116] Temperaments should not be allowed to reduce administrative efficiency, and administrative work of each department should be constantly evaluated,[117] through tests to cover the seven aspects of administrative functioning. Keen watch should be kept over proper execution of administrative work without conspiracy or dissension, because, in either case, they would consume administrative integrity.[118] All work should be executed with the knowledge of superiors, except when emergencies arise. They should be prohibited from doing anything which would reduce the vitality of the state, either by undertaxing, or by overtaxing, the resources of the people.[119] State revenues should not be squandered so as to sap human incentives to activity.[120]

Excess of personal expenditure, dissipation of capital and miserliness of administrative personnel should be prohibited.[121] If any of the guilty officers happens to have a powerful following, his guilt should be suppressed; if he has none, he should be hauled up. The top administrators should hold enquiries over their departmental staff with the assistance of the inspecting staff.[122] Honest administrative personnel should be given permanent assignments.[123]

XIII

At this point, we get deeper into the concepts of economic planning, as developed by Kautilya, with a view to integral conservation of state resources. Economic planning has to cover three major functions of state craft: conservation of resources for sustenance of rural and urban areas; defence of the state and consolidation of its potential for attack in emergencies for which an all-comprehensive term is used: "Sarvarambhah" by Kautilya elaborated into "labha and palana," the second term including functions of sustenance, defensive functions and war-strategy.

In such a background, the pivotal position is occupied by the director of stores, who has to cover the state-requirements in goods, services and treasure. He exercises his control over the fields of agriculture, tax-collections in town and country, general commerce and barter, gifts in kind and grain, grain transactions, processing of food products, windfalls of revenue, general expenditure and recovery of outstanding dues.[124] Agriculture, produce of state lands, state-share of general farm output, provisions secured for the armed forces, sacrificial offering in kind levies (special) to royal occasions, marginal levies, compensatory extractions, tributes to royalty, irrigation cesses paid to the state for land under state irrigation projects, should all be supervised by the director of stores under "country" accounts. Similarly, his functions cover transactions in grain, including processing of all kinds of food crops including sugar and oil under the generic classification of Samhatika (2.15.8). Detailed description is given of all the different goods entering state stores extracted from different parts of the country like Sindh, the oceans and different

kinds of soil. Fruit essences are also described in detail along with varieties of spices. Methods for storing of different goods for as long as six months to a year are also indicated in great details under Sukta Varga.[125] Fruits are classified under Phalamla Varga.[126] Curds and other mild acids are described under Amlavarga.[127] Spices are enumerated under Katakavarga.[128] Cured fish, dried meat, roots, preserved fruit and vegetables are detailed in Sakavarga.[129]

Half of these stores must be kept as emergency reserves to meet times of scarcity, the other half released for present consumption.[130] Old stores must be replaced by new ones, from time to time.[131] Careful supervision should be exercised in ascertaining shortages of stores through processing them for consumption and storage. Percentage of shortage for each process is detailed in experimented tables.[132]

Any programme for grain and other food conservation must include a pattern of rationing, to which attention is paid next.[133] Rations are detailed for men and animals starting from the king and the royal family and ending with peacocks and red deer. Plans are drawn up for the utilisation of charcoal and chaff.[134] The instruments used in weighing, grinding, pounding, winnowing of grain and other articles are described in detail.[135] The kinds of labourers[136] employed in food conservation are described. So also methods for storing of diffeent kinds of food articles from grains to oil and salt, so as to preserve them fresh for different periods of time.

Commerce, which would develop around such a pattern of commodity conservation, is to be supervised by a director of trade.[137] He should supervise[138] all merchandise flowing in through land and water routes and their respective prices, and market[139] prices should be determined[140] after centralising[141] the merchandise. Internal goods and royal commodities should have standardised markets.[142] Foreign goods must be dispersed.[143] Both these goods must be sold in a manner to facilitate consumption by the people.[144] Exploitation of markets or of consumers is not permitted.[145] Commodities in constant demand should have no restricted time of sale or monopolistic practices.[146] Subsidised pedlars[147] shall sell state goods at fixed

prices over diffused markets. Purchase bonuses in the shape of extra measure,[148] extra weight and extra quantity should be allowed on all goods as detailed. Special favours should be shown for foreigners' goods[149] and foreign merchants and mariners in the form of tax-exemptions and subsidies.[150]

Having thus outlined the technique for control and regulations of internal trade,[151] Kautilya turns to outline the techniques for the control and conservation of foreign trade.[152] Competitive prices for local and foreign goods should be ascertained, in attempting to fix the terms of barter,[153] after making allowances for taxes and duties, conveyance and transit charges and maintenance expenses for the traders. If markets abroad turn unfavourable, goods should be diverted to other land markets to secure better barter terms of exchange. Contacts may be secured with the foreign defence and security personnel for benefit of the mother country. If foreign markets cannot be reached, he should sell his goods in free markets.[154] In foreign trade, one should seek the most profitable markets and avoid losses.[155]

Comprehensive plans are outlined for conservation of gems and precious metals, for mines and mineral products, mints and coinage, with separate directors and controllers for each activity. We also get descriptions of offices of director of forests, controller of armoury, controller of weights and measures, with detailed measurements of time, quantity and space. Control of urban trade is regulated through the director of tariffs, who has to administer the sanctioned code of tariffs. Certain goods for social and religious purposes are exempt from tariff. Some articles of defensive and military significance are forbidden to be imported and are to be sold only to the government. The principle underlying control of movement of goods into urban areas is to shut off harmful goods and to allow beneficial goods free of all tariff,[156] as well as seeds which are unprocurable in the state.

Factory planning is indicated in the section on director of textiles.[157] Here employment of workers is on social security basis, covering widows, the handicapped, destitute girls, old courtesans, palace maids, in specific processes of textile manufacture.[158] Wages are adjusted to the quality of product turned

out and barter bonuses for extra good work are detailed. Expert weavers are also employed, employer-employee good relations are stressed, except unsavoury fraternisation with female workers. Facilities for women to work in their domestic environments are also provided. In fact, the system almost resembles the dormitory system operating in small-scale textile and other industries of Japan, where girl workers predominate.

Farm planning is outlined in the section on the director of farming,[159] whose functions cover all aspects of agriculture, horticulture and botanical sciences and arts. He should arrange for cultivation of state lands [160] with free and forced labour. He should arrange for farming implements.[161] Meteorological forecasts, helping farming operations should be properly serviced and farming processes adjusted. Facilities should be provided for the cultivation of uncultivated lands by granting concessions and subsidies. Cultivation under private irrigation should be encouraged by tax and cess exemptions. Crop and product planning on different kinds of land are detailed, so also the cultivation of medicinal herbs and plants. Farming wages are indicated in produce, according to work turned out. Grain collections should be made as often as harvests are gathered.[162]

These short sketches of the various fields of economic activity covered by detailed planning, as conceived by Kautilya, give us a glimpse of the type of monocyclical planning which he promulgated for strengthening the state so as to render it impregnable from within and invincible from without. The single idea dominating the entire structure of planning was loyalty to the state and loyalty to tradition, as conceived by Order and Discipline and to the ancient texts in which the institution is more significant than the individual, as long as that institution does not swerve from its loyalty to the environment, in which it is set. Where that loyalty is violated, the right to rebel against the environment reverts to the individual, not otherwise. This concept is fundamentally different from the Seiburgian concept of the German state as a destiny and not as a way of life. We learn "to that destiny the German individual citizen is prepared to sacrifice his mind, his independence, if necessary his life."[163] In Seiburg's own language: "What distinguishes us from other

nations is the bounds we set to the instinct of self-preservation."[164]
"We are shifting sand, yet in every grain there inheres the longing
to combine with the rest into solid durable stone."[165]

To Kautilya, the state is a "destiny" sanctified by accepted
tradition welded into a monolithic institutional pattern in
which the individual seeks adjustment with his environment
through the state, reserving his right for revolt when the state,
personified in the ruler, swerves from its own loyalty to accepted
and ennobled paths of Dharma, Artha and Kama, which help
to preserve balance between political, economic and social
forces, essential for progressive survival of the state and the
individual. Since the strength of the state is to be derived from
environment, regulation of the environment is essential for
rendering it invincible both within and without. Conservation
of environmental resource is the keystone of monocyclical plan-
ning, as conceived by Kautilya, and demonstrated by the meti-
culous care which is bestowed, on different functionaries and
fields of activity, which are considered essential for the balanced
survival of the state and consolidation of its administrative,
economic and social structure.[166]

The need for planning in the monocyclical age (kali yug)
springs from the deterioration of the innate automatic potential
for balance among the four basic attributes of human existence,
which survived through the processes of evolution in the other
three ages, we have already indicated. Thus, only greater dis-
cipline in the diverse fields of human activity can preserve the
essential balance for progressive survival of the state which is an
institutional necessity for human advancement. The state has
three major functions which are to be forged into the requisite
pattern of progress : the political or administrative, the economic
and the social, representing the three purustarthas of existence,
as we have already outlined. Crisis of loyalty and character
which characterises specially the monocyclical age, as detailed
by a host of Indian writers on the subject, calls for meticulous
planning or adjustment in every field of activity, if mankind is
not to be exterminated in a fundamental anarchy of culture and
tradition. The need for economic planning arises therefore, if
humanity is to be preserved from such an unenviable destiny. [167]

Therefore, everyday life in all its multifarious aspects comes in for careful regulation and adjustment, from the cooking-pot to the crown, with a view to conservation of resources to construct a responsive secular environment.

As we descend from general economic planning to urban planning, we cover fields like intoxicants, sex life, meat supply, conveyance on land and water, dairying, war equipment such as elephants and chariots, immigration and emigration and general urban living. If we take the controller of intoxicants, as an instance for illustrating planning of ordered urban existence, his duties begin in cities and extend to armed camps,[168] in ensuring supply and sale of wines and spirits. Sale of liquor is restricted to reputed persons in small quantities.[169] Vigilance should be kept on the customers of bars selling liquor to prevent extravagance.[170] Bars should be decorated with seasonal flowers.[171] Various kinds of liquor are described in detail. Special occasions for licensing of private brewing are mentioned and penalties for unauthorised brewing and sale of intoxicants are also detailed.

Similarly, public sex life is regulated by the controller of courtesans.[172] A court courtesan is appointed on the basis of her beauty, charm and talents on a fixed annual salary. And a counter-courtesan is also appointed on state salary, which would be half of that of the court courtesan. Courtesans have several ceremonial duties assigned to them and are classified into different gradations. An ex-courtesan becomes a nurse. A courtesan, who retires on private patronage, should pay compensation to government for the loss of her services. The controller should examine the private budgets of courtesans, to check extravagant expenditure. The rights of courtesans are protected by government. The same rules and protection cover other professional entertainers also.[173] Teachers of these classes of citizens are to be maintained by the state on government pay rolls. More competent of courtesans should be employed as espionage personnel on foreign spies. One could here compare the careers of Mata Hari, the notorious female spy and the use of call girls in American big business publicised in the General Electric trial of 1957 and the radio broadcasts of Murrow.[175]

Such instances could be multiplied, though state patronage and
subsidy for those in the musical and entertainment professions,
on any organised scale, are scarce even in modern states. Was
the Kautilyan plan in social security more comprehensive, in the
coverages of professions and personnel, than its modern versions?

The city administration is in the hands of an important urban
functionary. He should know the entire city through his
inspectors,[176] who are to keep detailed accounts of groups of
families to the extent of knowing their ancestry, name and voca-
tion of each member and the family budget.[177] He should also
possess information about the movements of individuals and
control the movements of strangers and foreigners, through rest
house managers and restauranteurs.[178] Doctors are also to
report casual patients to the authorities. Fire control measures
to be adopted by householders are detailed, specially applicable
to congested localities. Violation of precautionary measures
is to be punished. Cleanliness of public places is a civic duty,
violation of which carries penalties. Curfew arrangements,
signalled by trumpet-calls, are also detailed and exemptions
from curfew are indicated. Some nights are curfew-free.[180]
Restrictions on movements of householders are also defined.
Lost properties should be safeguarded. Prisons should be
emptied of prisoners who have served their sentence, or whose
sentences have been compounded by payment of ransom, and
on special state celebrations.

XIV

Perhaps the youngest and the most vital field of state-craft dealt
with in the present abridged version of Kautilya's Arthasastra
is the field of external relations and diplomatic planning. Differ-
ences in conception and functioning of institutions in this field
arise from "variation in national character, traditions and
requirements."[181] It may range from the mercantile diplomacy
of the British, the small power diplomacy of the oriental
type, the "macht-politik" or "blitz politik" diplomacy of the
Germans leading to "Einkreisung" or encirclement of states,
the survival of "boudoir diplomacy" of the French, to the mobile

diplomacy of the Italians.[182] Kautilyan concept of diplomacy springs from two basic ideas of state-craft, epitomised in two words : world conquest and world consolidation.[183] This leads us to the sixfold state policy[184] and the acceptance of the inevitability of the concepts of progress, stagnation and deterioration of the powers of states.[185] Well-consolidated, a state can evolve itself into a world-power.[186]

The sixfold state policy comprises of war, peace, neutrality, invasion, alliance and biformal relations, implying war with one state and peace with another, to be varied according to the might of the state employing these policy relations and the environment calling for a particular type of diplomacy. No state should launch into any policy line which would lead it to political and economic attrition and disaster. In fact, diplomacy should be so employed as to progress a state from a condition of deterioration to that of stabilisation, and from stabilisation to advancement.[187] This approach definitely highlights variation of policy relations to suit environmental dynamics of political situations. To the oppressed, the consolation is that "a wheel always turns," expressed by the Polish general in signing the instrument of surrender in the Second World War[188] and, to the aggressor, the slogan is the Hitlerite version of war "for the honour and the vital rights of the German people."[189] To Kautilya, war is an inevitable expression of might[190] for any state which seeks progress through expansion of its territories. Diplomacy is an instrument to further the objectives of state consolidation and state advancement.

In a situation where advancement can be attained either by peace or by war, the former is to be preferred in view of the disasters consequent on war. Similar preference is indicated in case of neutrality and war.[191] War and peace strategies are elaborated for states in different stages of evolution: major states, medium states and minor states. As a contrast, the Machiavellian stand on the diplomacy of foreign relations can be stated: "A prince ought to have no other aim or thought than war ... this is the sole art that belongs to him who rules."[192]

The Kautilyan strategy of state expansion is much more complicated than the Machiavellian counterpart. A state de-

sirous of expansion of its power should seek the sixfold policy outlined above as the political environment demands. Peace pact should be made with cognate states; war should be waged on minor states.[193] No war should be waged with a major power, since such a war would destroy the attacker. Power always brings about peace among states of equal status.[194] A minor submissive state should be allowed to sue for peace: if such peace is not admitted, it may draw on the wrath of an alliance of states.[195] The fatal German strategy, in the early phases of the Second World War, demonstrates the truth of this precept. Machiavelli would observe: "The prince should read histories, and study the actions of illustrious men, to see how they have borne themselves in war, to examine the causes of their victories and defeat, so as to avoid the latter and initiate the former,"[196] but a truly dynamic historical environment would cast a mantle of invincibility on a state determined to chase its destiny over battlefields, as it did in the case of Hitlerite Germany in the last world war. No wonder Machiavelli becomes vague in his injunctions to an ambitious prince: "A prince ought to observe some such rules....increase his resources with industry in such a way that they may be available to him in adversity, so that if fortune changes, it may find him prepared to resist her blows."[197]

When the fortunes of war swing against a state, attacked by a powerful state, the defending state should sue for peace with surrender of monetary indemnity or army or territory.[198] In peace diplomacy, equal care should be exercised to guard against sudden provocation and conflict and garner as much of good as circumstances permit.[199] The strategy of alliances of states is also detailed at great length.[200] Alliances must be forged with a view to self-fortification by states. Agreements for acquisition of land by states, for colonisation of no man's land are next dealt with along with the strategy of encirclement of states. Invasion strategy is elaborated with special attention paid to the invader, the overrun and the rear states. The special problems relating to foreign relation of buffer states, neutral states and alliances of powers are also dealt with.[201] The supremacy of diplomacy, adjusted to the contemporary political environment and enlightened by complete knowledge of the diplomatic weapon to be

employed in a given situation, is extolled by Kautilya, as enabling a state to completely encircle and entangle the less fortunate states in the web of successful strategy and disaster of the states with which diplomatic relations are to be constructed.[202] Thus, the master of the sixfold policy of international relations can play with the destiny of states and rulers enchained by diplomatic shackles fabricated by himself.

The final section of the abridged version of the Arthasastra presented here, concerns states in a state of storm and factors which brew crises and distress for the states.[203] These factors may spring from faulty pursuit of state policy or pursuit of wrong policy or errors created by men, by destiny or by natural calamities.[204] The Kautilyan thesis is that financial crisis is the most vital of all other crises afflicting a state, since finance is the foundation of all authority and in a financial crisis, authority is undermined or/and destroyed. Thus weakening of authority would infect all aspects of life affecting general prosperity, internal tranquillity and external relations.[205]

Popular distresses and crises stem from anger and ambition: anger produces three kinds of distress and ambition, four. Lack of knowledge and lack of discipline are the parents of popular distress. Hatred, multiplication of enemy troubles and courting distress are the three aspects of anger. Defeat, or degradation, financial ruin, despicable company and blackmail spring from ambition.[206] The fourfold vices created by desire are hunting, gambling, women and wine.[207] These dissipate resources and such dissipation of resources would generate calamities by sapping the sources of livelihood. Dissipation of resources arise from gift, exaction, blackmail and abandonment.[208] After describing the evils of gambling, hunting and women, Kautilya enumerates the evils of drinking as consisting of loss of sense, insensibility, cadaverous appearance, nakedness, loss of knowledge, of life, of wealth, and of friends, separation from goodmen, courting of disasters, indulgence with low society and with wasters of resources.[209] Control of these disintegrating and devastating forces can only come through education and discipline, since ignorance and indiscipline are the cause of popular disasters.[210] Education and discipline must be used to promulgate an environ-

ment, where popular distresses, arising from the forementioned evils, are controlled. Elimination of the forces of distress, control and remedy of distresses when they occur, and avoidance of financial stresses and strains, should be carefully planned by the state.[211]

According to Kautilya, the strength of the state must be consolidated by careful planning of *dharma*, *artha* and *kama* and through internal regulation of crises and strategic control of external relations. This can be said to be the central plank of what may be connoted as monocyclical planning, specially devised to suit the environmental pattern of an epoch in which the three basic forces of human progress are out of balance with each other. Authority, resource and relations (social and diplomatic) which represent the three traditional *purusharthas* of Dharma, Artha and Kama, are to be recognised as vital factors for the survival of the human race, and it is in devising strategy and planning, which would draw these three basic forces of ordered survival into a pattern of human advance, that Kautilya can be said to have released a thought-stream which transcends temporal and spatial limitations and to have earned a respected place among the giant architects of human progress and peaceful prosperity for the peoples of the world.

NOTES*

1. Ena sastram cha sastram cha Nandaraja gata cha Bhuh Amarshenochutanyasu tena sastramidam kritam, 15.1.73.

2. Kautiliya Arthasastra Part I, pp. 1-5.

3. Sastram cha Sastram cha.

4. Prithivya labhe palane cha, 1.1.1.

5. Vishnuguptena Mauryarthe.

6. Avapthan palane choktam lokasyasya parasya cha : Dharmamartham cha kamam cha pravartayati pati cha, 15.1.71-72.

7. Vajrajwalana tejasah; saktidharopamah, Namstasmai Vishnuguptaya Vedhase.

8. Dristva vipratipattim bahudha sastreshu bhashyakaranam svayameva Vishnuguptaschakara sutram cha bhashyam cha.

*Diacritical marks are not placed for these extracts in Sanskrit from Kautilya's Arthasastra. Other references are suitably indicated.

9. Arthamulau hi dharma kamau, 1.7.7.

10. Chakramekam na vartate, 1.7.9.

11. Lokapriyatvam arthasamyogena, 1.7.1.

12. Dharmarthau yad vidyat tat vidyanam vidyatvam, 1.2.9.

13. Pradipah sarvavidyanam upayah sarvakarmanam Asrayah sarvadharmanam sasvadanvikshiki mata, 1.2.12.

14. Trayyabhirakshito lokah prasidati na sidati, 1.3.17.

15. Dharmadharmau trayyam Arthanarthau Vartayam Nayaapanayau Daandnityam, 1.2.11.

16. Vyasana abhyudaye cha buddhimavasthapayati pragna vakya kriya aisaradyam cha karoti, 1.2.11.

17. *The Prince*, Ch. III.

18. Svadharmah, svargayanantyacha Tasyatikrame lokah sankaraduchidyeta, 1.3.14-15.

19. Vyavastitarya maryadah kritavarnasramasthitih, 1.3.17.

20. Suvignata pranito hi dandah praja dharmartha kamairyojayati, 1.4.11.

21. Tasmaddandamulastisro vidyah, 1.5.1

22. Srutaddhi pragnopajayate pragnaya yogo yogada tmavattete vidyanam samarathyam, 1.5.16.

23. Vidya vinito raja hi prajanam Vinaye ratah ananyam prithivim bhunkte sarva bhuta hite ratah, 1.5.17.

24. Vidya vinaya heturindriya jayah, 1.6.1.

25. Kama krodalobhamana mada harsha tyagat karyah, 1.6.1.

26. Sabdasparsa rupa rasa gandha, 1.6.2.

27. Sahayasadhyam rajatvam chakramekam na vartate kurvita sachivanstasmathesham cha srunuyanmatam, 1.7.9.

28. Arthamulau hi dharmakamau, 1.7.7.

29. Kamadhi rutsekah svah prakrutih kopayati, apanavo bahyah, 9.7.1.

30. Tadubhayam Asurivrithih, 9.7.1.

31. Artho dharmah kama iti arthatrivargah, Anartho adharmo sokah iti anarthatrivargah, 9.7.60-61.

32. Dharmasastrani manvadini, arthasastrani kautilyadini, kamasastrani vatasyayanadini.

33. *Diplomacy*, 1950, The Home University Library, pp. 75-76.

34. Atah padardha guna hinau madhyamavarau, 1.9.2.

35. Pratyaksha, parokshanumeya hi rajavrittih, 1.9.4.

36. Amatyanupadhabhih sodhayet, 1.10.1.

37. Sarvopadhya suddan mantrinah kuryat, 1.10.14.

38. Nicolson, op. cit., p. 91.

39. Indrasyahi mantriparishadrishinam sahasram. Sa Tachakshuh. Tasmadimam dwayyaksham Sahasrakshamahuh, 1.15.57.

40. Kritamahamatrapasarpah paura janapadanapasarpet, 1.13.1.

41. Nicolson, op. cit., p. 97.

42. Nicolson, op. cit., p. 98.

43. Tushtanarthamanabhyam Pujayet. Atushtan Samadanabheda dandaih

sadhayet, 1.13.25.

44. Evam svavishaye krityanakrityamscha vichakshanah paropajapatsamrkashet pradhanan kshudrakanapi, 1.13.26.

45. Kruddhalubdha bhitamaninastu paresham krityah, 1.13.22.

46. Labheta samadanabhyam krityamseha parabhumishu. Akrityan bhedadandabhyam paradoshamscha darsayan, 1.14.12.

47. Upajapa, vide 1.14.

48. Mantrapurvah sarvarambhah, 1.15.2.

49. Pakshibhirapyanalokyasyat, 1.15.4.

50. Suka sarikabhirmantro bhinnah, 1.15.4.

51. Pramadamadasuptapratapah kamadirutsekah, 1.15.11.

52. Tasmadrakshet mantram, 1.15.12.

53. Desakala karya vasena . . . yathasamarthyam mantrayeta, 1.15.41.

54. Tamekaikasah prichchet samasthamseha, 1.15.43.

55. Yatha samarthyam, 1.15.50.

56. Indrasya hi mantriparishadrishinam sahasram, 1.15.55.

57. Atyayike karye mantrino mantriparishadam chahuya bruyat, 1.15.59.

58. Yadbhuyista bruyuh karyasiddhikaram va tatkuryat, 1.15.59.

59. Udvrutamantro dhutapranidhih, 1.16.1.

60. Amatyasampadopeto Nisrustarthah, 1.16.2.

61. Suprati vihita yana vahana purusha parivapah pratishteta, 1.16.5.

62. Vide op. cit., pp. 119-122.

63. Dutamukhahi Rajanah, 1.16.19.

64. 1.16.33-34. Preshana sandhipalatvam pratapo mitrasamgrahah upajapah suhrudshedo gudadandatisaranam Bandhuratnapaharanam charagnanam parakramah samadhimoksho dutasaya karma yogasya chasrayah.

65. Rakshitoraja rajyam rakshatyasannebhyah parebhyascha purvam darebhyah putrebhyascha, 1.17.1.

66. Janmaprabhruti rajaputran rakshet karkatakasadharmano hi janaka bhaksha rajaputrah, 1.17.4-5.

67. Tasmaddharmyam arthyamcharyopadiset nadharmyamanarthyam cha, 1.17.33.

68. Na chaikaputram avaneetam rajye sthapayet, 1.17.51.

69. Jyesthabhagi tu pujyate, 1.17.51.

70. Rajaputrah. . . Pitaramanuvarteta, 2.18.1.

71. Tyaktam gudapurushah sastrarasabhyam hanyuh, 1.19.14.

72. Putravamstu pravasayet, 1.18.16.

73. Tasmadhuthanamatmanah kurvita, 1.19.5.

74. Atmabalanukulyena va nisaharbhagan pravibhajya karyani seveta, 1.19.25.

75. Karyarthinamadvarasangam karayet, 1.19.26.

76. Prajasukhe sukham ragnah prajnam cha hite hitam natmapriyamhitam ragnah prajanam tu hite hitam, 1.19.34.

77. Raja kuryadarthanusasanam. Arthasyamulamuthanam anarthasya viparyayah, 1.19.35.

78. Atmasastragrahadhishtitah siddhatapasam pasyet, 1.21.24.

79. Rakshet purva kritan raja navamschabhi pravartayet, 2.1.39.

80. Bhutapurvamabhutapuravam Paradesapavahenana Svadeshabhi shyandavamanena va nivesayet, 2.1.1.

81. Kulasatavaram panchakulasataparam gramam, 2.1.2.

82. Krosadvikrosa seemanamanyonya raksham nivesayet, 2.2.2.

83. Sthaniya.

84. Dronamukha.

85. Kharvatika.

86. Sangrahana.

87. Dhanya pasu hiranyaischaitananugrinheeyat, 2.2.13.

88. Chaitebhayah kosavriddhikarau dadyat, kosopaghatakau varjayet, 2.1.15.

89. Nicruttapariharan pitevanugrinheeyat, 2.1.18.

90. Akarakarmantadravyahastivana Vraja Vanikpatha pracharan varisthala patha panya pattanani cha nivesayet, 2.1.19.

91. Raja svamyam gachet, 2.1.24.

92. Dasahitakabandhunasrunvato raja vinayam grahayet, 2.1.25.

93. Balavridha vyasanyananathamscha raja bibhruyat striyamaprajatam prajatayascha putran, 2.12.6.

94. Grama Vriddhah Vardhayeyuh, 2.1.27.

95. Striyam cha pravrajayatah, 2.1.29.

96. Nacha tatrarama viharartha va salah syuh, 2.1.33.

97. Na karma vighnam kuryuh, 2.1.34.

98. Nirasrayatvat gramanam kshetrabhiratatvachcha purushanam kosavistidravyadhanyarasa vriddhirbhavati, 2.1.35.

99. Pradhistabhaya sthavarajangamani cha brahma somaranyani ... prayacchet, 2.2.2.

100. Mrigavanam ... nivesayet, 2.2.4.

101. Hastivana and nagavana, 2.2.6-10.

102. Hastikula, 2.2.10.

103. *Arthasastra*, Kangle Edition, Footnote to p. 35.

104. Tesham nadiparvatadurgam janapadarakshasthanam dhanvana vanadurgam atavisthanam, 2.32.

105. Sannidhata kosagriham panyagriham, koshtagaram, kupyagrihamayudhagaram bandhanagaram cha karayet, 2.5.1.

106. Asuddham chedayet, 2.5.10.

107. Atma purushadhistitah...nichayananutishtet, 2.5.21.

108. Bahyamabhyantaram chayam vidyadvarshastadapi yatha priste na sajjeta vyaye seshe cha sanchaye, 2.5.22.

109. Durgam rashtram khanim setum vanam vrajam vanikapathamchavaiksheta, 2.6.1.

110. Evam kuryatsamudayam vriddim chayasya darsayet. Hrasam vyayasya cha pragnah sadhayeccha viparayayam, 2.6.28.

111. Aparadham sahetalpam tushedalpepi chodaye mahopakararr cha-

dhyaksham pragrahanabhipujayet, 2.7.41.

112. Kosapurvah sarvarambhah. Tasmatpurvam Kosamaveksheta, 2.8.1-2.

113. Prachara samruddhischaritranugrahaschoranigraho yukta pratishedah sasyasampatpanyabahulyamupasarga promokshah pariharakshayo hiranyopayanamiti kosa vriddhih, 2.8.3.

114. Pratibandhah prayogo vyavaharo avastarah parihapanamupabhogah parivartanamapaharascheti kosakshayah, 2.8.4.

115. Amatya sampathopetah sarvadhyakshah saktitah karmasu niyojyah, 2.9.1.

116. Karmasu chaistham nityam pariksham karayet chittanityatvanmannshyanam, 2.9.2.

117. Tasmatkartaram karanam desam kalam karyam prakshipamudayam chaishu vidyat, 2.9.4.

118. Samhata bhakshayeyuh vigruheeta vinasayeyuh, 2.9.6.

119. Yat samudayam parihapayati sa rajartham bhakshayati yah samudayam dvigunamudhavayati sa janapadam bhakshayati, 2.9.13-15.

120. Ya samudayam vyayam upanayati sa purushakarmani bhakshayati, 2.9.17.

121. Mulaharatadatvika kadaryamscha pratishedayet, 2.9.20.

122. Tasmadasyadhyakshah sankhyayaka lekhaka rupadarsaka nivigrahakottaradhyakshasakhah karmani kuryuh, 2.2.82.

123. Na bhakshayanti yetvarthan nyayato vardhayanti cha nityadhikarah karyaste ragnah priyahite ratah, 2.9.36.

124. Sitarashtra krayimaparivartaka pramityakapamityaka samhatikanyaata vyaya pratyayopasthananyupalabheta, 2.15.1.

125. 2.15.17.

126. 2.15.18.

127. 2.15.19.

128. 2.15.20.

129. 2.15.21.

130. Tatordhamapadartham janapadanam sthapayet ardhamupayumjeeta, 2.15.22.

131. 2.15.23.

132. 2.15.25-41.

133. Vidhapramanam, 2.15.50.

134. Angaramstushan lohakarmanthabhitthi lepyanam harayet, 2.15.60.

135. Upakarnani, 2.15.62.

136. Vishtih, 2.15.64.

137. Panyadhyakshah, 2.16.

138. Vidyat, 2.16.1.

139. Vikshepasankshepa kraya vikraya kalan vidyat, 2.16.1.

140. Arthamaropayet, 2.16.2.

141. Ekikritya, 2.16.2.

142. Svabhumijanam rajapanyanam eka-mukham vyavaharam sthapayet, 2.16.4.

143. Parabhumi janamaneka mukham, 2.16.4.

144. Ubhayam cha prajanamanugrahena vikrapayet, 2.16.5.

145. Labham prajanam aupaghatakam varayet, 2.16.6.

146. Ajasrapanyanam kaloparodham sankuladosham va notpadayet.

147. Vaidehakah, 2.16.9.

148. Manavyaji, 2.16.10.

149. Anugrahena vahayet, 2.16.11.

150. Pariharamayatikshamam dadyat, 2.16.12.

151. Svavishaye, 2.16.17.

152. Paravishayetu, 2.16.18.

153. Panya pratipanya nayanena ... labhanpasyet, 2.16.19.

154. Sarvadiya visuddham vyavahareta, 2.16.23.

155. Yatolabhastato gachhet alabham parivarjayet, 2.16.25.

156. Rashtra pidakaram bhandamuchhindhyadaphalam cha yat, mahopakaram uchchulkam kuryad bijamcha durlabham, 2.21.31.

157. Sutradhyakshah, 2.23.

158. Vidhavanyanga kanya pravrajita dandapratikarinibhi rupajivamatrikabhirvriddharajadasibhirvyuparatopasthana devadasibhishcha kartayet, 2.23.2.

159. Sitadhyakshah, 2.24.

160. Svabhumau, 2.24.2.

161. Karshanyantropakarna balivardaischai ... 2.24.3.

162. Yathakalam cha sasyadi jatam jatam pravesayet na kshetre sthapayetkinchit-palalamapi panditah, 2.24.31.

163. Nicolson, *Diplomacy*, p. 146.

164. Ibidem.

165. Op. cit. p. 145.

166. Tasmatsvadharmam bhutanam raja na vyabhicharayet, 1.1.3.16. Vyavasthitarya maryadah kritavarnasrama sittitih trayyabhi-rakshito lokah prasidati na sidti, 1.3.17. Chaturvarnasramo loko ragna dandena palitah sva dharma karmabhirato vartate sveshu vartmasu, 1.4.16. Vidyavinito raja hi prajanam vinaye ratah ananyam prithivim bhunkte sarvabhuta hite ratah, 1.5.17.

167. Arthaeva pradhana iti kautilyah Arthamulauhi dharma kamau iti, 1.7.6-7.

168. Durge janapade skandavare va...eka mukhamaneka mukham va vikrayakrayavasena va, 2.25.1.

169. Gnata saucha nirhareyuh, 2.25.4.

170. Panagareshu.

171. Panoddesani gandharvalyodakavanti ritusukhani karayet, 2.25.11.

172. Ganikadhyakshah, 2.27.

173. Natanartaka gayana vadaka vagjivana kusilava plavaka saubhikacharananam strivyavaharinam striyo gudajivascha, 2.27.25.

174. Gitavadya patyanritta natyakshara chitra veena venu mridanga parichitta gnana gandha malya samyuhana samvadana samhahana vaisika

kala gnanani ganika dasi rangopajivisusch grahayet rajamandaladajivam kuryat, 2.27.28.

175. Vide, *They Sell Sex* by Sara Harris, Fawcett Publications, 1960.

176. Gopah, 2.36.2.

177. Ayavyayaucha vidyat, 2.36.3.

178. Dharmava sathinah ... 2.36.5.

179. Agni pratikaram cha grishme, 2.36.15.

180. Chararatrishu ... 2.36.39.

181. Nicolson, op. cit., p. 127.

182. Vide, op. cit., chapter VI, pp. 127-153.

183. Prithivya labhe palane cha, 1.1.1.

184. Shadgunya samuddesah, 7.1.1.

185. Kshayah sthanam vriddhirityudayasthasya, 6.2.5.

186. Nayagnah prithivim kritsnam jayatyeva na hiyate, 6.1.18.

187. Evam shadbhirgunairetaih sthitah prakriti mandale paryesheta kshayatsthanam sthanad-vriddhim cha karmasu, 7.1.38.

188. Vide, *The War—1939-45*, Edited by Flower and Reeves: Cassell, London, 1960, p. 12.

189. Op. cit., p. 3.

190. Abhyuchheeyamano Vigrinhiyat, 7.1.14.

191. Sandhivigrahayo-sthulyayam viruddhau sandhi-mupeyat Vigrahe hi kshaya vyaya pravasa pratyavaya bhavanti. Tenasana yanayorasanam vyakhyatam, 7.2.1-3.

192. *The Prince*, Ch. xiv. Great Books of the World. Encyclopaedia Britannica, 1952, 0.21.

193. Samajjyayobhayam sandhiyeta, hinena vigrinhiyat, 7.3.2.

194. Tejo hi sandhana karnam, 7.3.8.

195. Hinaschetsarvatranupranastishtet sandhimupeyat ... Mandalasya chanugrahyo bhavati, 7.3.10-12.

196. Op. cit., p. 22.

197. Ibid.

198. Kosadandatma bhumibhih, 7.3.22.

199. Adau budhyeta panitah panamanascha karanam tato vitarkyobhayato yatah sreyastato vrajet, 7.7.31.

200. Evam drustva dhruve labhe labhamse cha gunodaye. Svartha siddhiparo yayat samhitah samavayikaih, 7.9.53.

201. Madhyama charitam, udasinacharitam and mandalacharitam, 7.18.

202. Vriddhim kshayam cha sthanam cha karsanochcheadanam tatha sarvopayan samadadhyadetan yaschartha sastravit. Evam anyonyasancharam shadgunyamyonupasyati sa buddhinigalairbaddhairishtam kridati parthivaih, 7.18.43-44.

203. Vyasanadhikarikam, 8.

204. Daivam manusham va prakruti vyasamananaya panayabhyam sambhavati, 8.1.2.

205. Kosamulohi dandah kosabhave dandah paramgachchati, svaminam

va hanti sarvabhiyogakarascha koso dharma kamahetuh. Desakalakarya-vasena tu kosa dandayoranyatarah pramanibhavati Lambapalanohidandah kosasya, kosah kosasya dandasya cha bhavati Sarvadravya prayojakatvat Kosavyasanam gariyam, 8.1.47-52.

206. Dveshyata satruvedanam duhkha sangascha l.opah paribhavodravya-nasah patachcharadyutakara lubdaka gayanavadakaih chanaryaih samyogah kamah, 8.3.14-15.

207. Kamajasthu mrigaya dyutam, striyah, panamiti chaturvargah, 8.3.38.

208. Vrithivilopastu arthadushanam. Adanamadanam vinasah parityago varthasyetiarthadushanam, 8.3.29.

209. Samgnanasonunmathasyunmaththatwatmapretasya pretatvam kaupi-nadarsanam srutapragnaprana vittamitra hanih sadbhirviyogonarthyasamyo-gsathantrigitanaipunyeshu charthagneshu prasanga iti, 8.3.61.

210. Avidyavinayah purusha vyasanahetuh, 8.3.1.

211. Pidananamanutpattah utpannanam cha varane yateta desavriddhya-rtham nase cha stambha sangayoh, 8.4.50.

Book I

DISCIPLINE AND ENVIRONMENT

Chapter 1
KNOWLEDGE

KNOWLEDGE comprises of philosophical lore, scripture, occupational sciences and the science of government.

According to one school of thinkers, knowledge has only three fields: scripture, occupational sciences and the science of government.

According to another, it has only two fields: occupational sciences and the science of government; scripture being only the essence of experience and faith.

One writer confines human knowledge to only one field: the science of government.

Kautilya holds that there are four fields of knowledge: metaphysics ennobling the physical and the intellectual life of man; scripture dealing with the right and the wrong; occupational sciences revealing the wealth and the non-wealth; and the science of government revealing the apt and the inapt, the powerful and the nonpowerful.

That which endows a being with tranquillity of mind in opulence and distress and with wider vision, finer thought, clarity of speech and dexterity of action is metaphysics. It is this which lights up all knowledge, begets all virtues and assists all actions.

Chapter 2
VALUE OF KNOWLEDGE

THE three scriptural streams consist of the chant, the hymn and the sacrifice. These, along with the magical lore and the ancient legend are the holy knowledge.

The three scriptures are most useful in that they determine the form and function of the four divisions of the social structure.

Learning, teaching, sacrifice, ceremonial office, charity and

47

receipt of gifts are the duties of the intellectual classes.

Study, sacrificial offering, charity, fighting and protection of life, the duties of the warrior classes.

Study, sacrificial offering, charity, farming, cattle-culture and trade are the duties of the trading classes.

Service of society, farming, cattle-culture, trade, artisanship and entertainment are the duties of the service classes.

A householder earns his living by his profession, marries among equals of different ancestry, has sex relations with his own wife after her monthly periods, offers gifts to his gods, ancestors, guests and servants.

A student learns the scriptures, performs worship and offers ablution, lives by alms and is devoted to his teacher or the teacher's family or to an elder scholar.

A forest recluse observes chastity, sleeps on the bare ground, wears animal skins, does fire and god worship, offers homage to his ancestors and guests, and lives on the resources of the forests.

A wandering ascetic completely controls himself, does not work, has no money, lives away from social contacts, moves from place to place and lives a pure and retired life.

Mercy, truth, purity, love, kindness and pardon are duties common to all.

Performance of one's duties leads to paradise and peace. With its violation, the world will end in anarchy of castes and duties.

The ruler should maintain people in the performance of their duties. This is the path to peace and progress. The world kept in accordance with the scriptural injunctions will progress and endure.

Chapter 3

VALUE OF KNOWLEDGE

FARMING, cattle-culture and commerce form occupational science. This science gives us grain, cattle, gold, forest wealth and human labour. It is by the treasure and army got through

occupational science that the ruler can control his own party, as that of his adversaries.

The sceptre of authority on which the sustenance and prosperity of all branches of knowledge depend is government. Government is treated by the science of government.

It helps to acquire resources, to secure them, to preserve them and to distribute the benefits of improvement among the deserving. The progress of the world is based on the science of government.

One teacher says that authority must be upheld by anyone desiring the progress of the world. There is no better instrument for controlling the people.

He who gives severe punishment is hated by people. He who gives mild punishment become contemptible. He who awards punishment justly deserved, is respected. Just punishment keeps people in the path of right—industrious and cultured. Punishment coloured with greed or anger incites even hermits, let alone householders.

When authority is neutralised, anarchy, as in the parable of fishes, reigns: the strong will devour the weak. Under authority, the weak will resist the mighty.

The people, cast in fourfold social system and duties, will respect paths of duty under good authority and society will advance.

Chapter 4
WISE COUNSEL

THE science of government is the basic strength of all sciences. Authority depends on discipline.

Discipline is of two kinds: artificial and natural. Education alone can render a proper recipient amenable to discipline and not a recalcitrant. Science can benefit only those who have developed faculties like obedience, power to listen, assimilation, memory, power of discrimination, power. of dedication and deliberation. On others, it would be a waste.

Special preceptors should give instructions in sciences and scientific discipline.

At the proper age, early, the student should learn the alphabet and numbers. After initiation, he should learn the scripture, philosophy, the science of occupations under government officials and the science of government under theoretical and executive politicians.

The ruler should remain chaste till sixteen years of age, when he should marry.

To keep powerful discipline, he should keep the company of mature men of sciences who alone are repositories of discipline.

The ruler should spend the mornings in lessons in military arts relating to elephants, horses, armoured vehicles and weapons and the afternoon in hearing News.

Legend, lore, narrative, parable, religion and strategy are covered by News.

During the rest of the day, he should receive new lessons and revise old ones. He should also learn what he has not clearly understood.

It is by listening that knowledge can be increased. Knowledge sharpens action and from action, self control is possible. That is the potency of education.

The ruler who is educated well and taught the sciences, who governs his subjects well and does good to all people will enjoy the earth unchallenged.

Chapter 5

CONTROL OF SENSES

CONTROL over senses is vital in ensuring success in study and discipline. This can be obtained by regulating lust, anger, greed, obstinacy, intoxication and exuberance.

Indifference to perception of sound, touch, colour, taste and smell is essential for victory over senses. Science gives one discipline in ensuring it.

He who cannot control his organs of sense will soon perish, even though he may possess the entire earth like those in the past who perished because of their infatuation for women, or because of anger against groups of individuals, or because of

greed for power and land, or because of inciting group hatred, or persecution of the pious.

Chapter 6

CONTROL OF SENSES

By conquering the six enemies of living (lust, anger, greed, vanity, haughtiness and exuberance) he (the ruler) shall acquire balanced wisdom. He shall keep company with the learned. He shall get information through his spies. By his actions, he shall set up safety and security. By enforcing his authority, he shall keep his subjects observing their duties and obligations. He shall exercise control over himself by learning sciences. He shall help his subjects to acquire wealth and do good to them.

In this manner, with control over his impulses, he shall abstain from hurting the woman and the property of others. He shall avoid lust, falsehood, hauteur and evil inclinations. He shall keep away from wrong and wasteful transactions.

He shall enjoy his lawful desires in conformity with the right and the economic. He shall pursue the three merits of living: charity, wealth and desire. Any one of these merits carried to excess not only hurts the other two, but itself.

Wealth is the foundation of the other two because charity and desire depend upon it for their fulfilment.

Teachers and ministers should keep the ruler away from dangers and warn him of time-schedules even in camera. Such teachers and ministers are always respected.

Authority is possible only with assistance. A single wheel cannot move by itself. The ruler, therefore, shall employ ministers and hear their advice.

Chapter 7

ADVISERS AND MINISTERS

"The ruler," says an ancient thinker, "should employ his classmates as his ministers. He can trust them because of his

own knowledge of their sincerity and capacity."

"No," says another, "because as they know the ruler, they would have contempt for him. But he should employ such as are well-known to him because of his knowledge of their secrets. They would not betray him for fear of their own secrets being laid bare."

"This fear may work in every direction," says still another. "The ruler may support them in their good and bad acts on the basis of the same fear of betrayal. Hence, he should employ as ministers only those who, in finances, can show as much or more receipts than expenditure and are of tried ability."

"These are narrow considerations," says another ancient thinker, "such persons have not other ministerial abilities. He should, employ as his ministers, those whose fathers and grandfathers had occupied similar posts before. Such persons, because of their inherited knowledge and contacts, never betray him. Similar faithfulness is almost an animal instinct as shown even among cows who do not desert their own herds."

"Not at all," says a fifth thinker, "such people acquire influence over the ruler and act as rulers themselves. He should, therefore, employ as his ministers such new persons as are proficient in the science of government. It is such persons who give due respect to the ruler as the bearer of true authority and will please him."

Another ancient authority does not agree with this view. "A person with only theoretical knowledge and no experience of government may make serious blunders in actual administration. Hence, the ruler should employ as ministers those with noble ancestry and wisdom, sincerity of purpose, bravery and loyalty. Ministerial appointments must be made purely on individual qualifications."

The last is satisfactory in all respects. A man's ability is measured by his capacity in work, and by differences in his working capacity.

The ruler must divide the spheres of the ministers' work in regard to place and time. But such persons should not be employed as advisers, but only as companions or administrators.

Chapter 8
ADMINISTRATORS AND SPIRITUAL ADVISERS

THE qualifications of an administrator consist of his being national, of high ancestry, influential, trained in pragmatic arts, of clear vision, blessed with wisdom, possessed of strong memory, of courage, eloquent in speech, diplomatic, intelligent, enthusiastic, possessed with dignity and capable of endurance, with pure character, sociable, with a keen sense of devotion, bestowed with high conduct strength, health, bravery; devoid of hesitation and weakness of mind, sincere and free from defects which incite hatred and enmity.

Those who posses only a half or a quarter of the above qualifications can be classed as ordinary or lower ranks of administrators.

Tests for these qualifications consist of the following :

Nativity and influence should be ascertained from reliable referees. Capacity in pragmatic arts, from eminent men in the field. Theoretical knowledge, foresight, memory and sociability should be assessed by tests in works. Eloquence, artistry and brilliance should be tested in conversation. Endurance, enthusiasm, fortitude in adversity, purity of life, sociability and loyalty should be tested by association; conduct, strenght, health, dignity, strength of mind and decision, from intimate friends. Affection and charity should be ascertained from personal experience.

The works of the ruler may be perceptive, imperceptive and inferential. That which he sees is perceptible; that which he is told by another is imperceptible; that which can be expected to be accomplished from what is accomplished, is inferential.

As all the works are not executed at once and vary in form and in localities, the ruler should, to keep abreast of time and place, appoint officers to carry them out. Such is the work of ministerial officers.

The ruler should appoint, as his spiritual adviser, one whose ancestry and character are high, who is well educated in scriptures, is an adept in the science of government, is sincere and diplomatic. Him the ruler should follow as a student his preceptor, a son his parent and a servant his employer.

Those rulers who are nurtured by the intellectual class, are blessed with eminent advisers and who follow the injunctions of sciences, become unconquerable and attain victory even without arms.

Chapter 9

TESTS OF FIDELITY OF MINISTERS AND ADMINISTRATORS

WITH the help of his chief minister and spiritual adviser, the ruler should test the character of administrators employed in departments, by offering temptations.

The ruler should feign dismissal of his spiritual adviser on the plea that he would not teach scriptures to the undeserving or officiate for an uninitiated person.

The dismissed adviser, with the help of spies disguised as classmates, tempt each officer by saying, "The ruler is outrageous. Let us set up another who is righteous and born of the same family or who is imprisoned. This is agreeable to us. What do you think?"

If any or all of the officers refuse the offer, he or they are pure. This is religious temptation.

An army officer, discharged for receiving bride, may by similar agency incite each officer to murder the ruler in view of thus acquiring great wealth. If they refuse, the officers are pure. This is monetary temptation.

A woman spy, posing as pious and close to the ruler's family may tempt the prime minister (or other high official) by saying: "The ruler's wife is enamoured of you and would receive you into her chamber." If they reject the offer, they are pure. This is love temptation.

Another, posing as a disciple, may incite each high officer: "The ruler has taken to unwise course. Let us rid ourselves of him and have another." If they refuse, they are pure. This is the fear temptation.

Of those officer, those who have resisted the religious temptation, should be employed in courts of justice. Those who

have withstood monetary temptation should be employed in revenue and tax work; those who are pure of love temptation should be employed in superintending entertainments; those who are tried under fear temptation should be employed in administrative service.

Those who have been tested under all temptations should be employed in high ministerial offices.

Those who are impure under any or all of these temptations should be employed in mines, forests (timber and elephant) and factories.

Except through agents, the ruler or his lady, should never attempt to test the character of his advisers. Sometimes the test may fail and have the opposite effect. The valiant-minded soul, when once disturbed by any or all of these tests, may not reach its pristine purity.

The ruler should find out purity or impurity of his officers through the agency of spies.

Chapter 10
ON SPIES

ADVISED and assisted by a tried council of officers, the ruler should proceed to institute spies.

Spies are in the guise of pseudo-student, priest, householder, trader, saint practising renunciation, classmate or colleague, desperado, poisoner and woman mendicant.

An artful person, capable of reading human nature, is pseudo-student. Such a person should be encouraged with presents and purse and be told by the officer: "Sworn to the ruler and myself you shall inform us what wickedness you find in others."

One initiated in scripture and of pure character is a priest-spy. This spy should carry on farming, cattle culture and commerce in resources given to him. Out of the product and profit accrued, he should encourage other priests to live with him and send them on espionage work. The other priests also should send their followers on similar errands.

Householder is a farmer, fallen in his profession but pure in character. This spy should do as the priest.

Trader-spy is a merchant in distress but generally trustworthy. This spy should carry on espionage, in addition to his profession.

A person with proper appearance and accomplishments as an ascetic is a saint spy. He surrounds himself with followers and may settle down in the suburb of a big city and may pretend prayer and fasting in public. Trader spies may associate with this class of spies. He may practise fortune-telling, palmistry and pretend supernatural and magical powers by predictions. The followers will adduce proof for the predictions of their saint. He may even foretell official rewards and official changes, which the officers concerned may substantiate by reciprocating.

Rewarded by the rulers with money and titles, these five institutions of espionage should maintain the integrity of the country's officers.

Chapter 11
TOURING SPIES

STATE'S orphans, fed and educated by the state, should be employed as social spies. They are to be trained in general science, magic (or conjuring), various orders of religious life, musical and dramatic arts.

Reckless persons, fearless of life and who face elephants and tigers in fight, to earn a living, are termed sharp spies.

Those who are devoid of affection and are cruel and lazy should be trained as poisoner-spies.

A poor widow of a high family, clever and anxious to earn her livelihood, can become a woman priest. Honoured in the lady's chamber of the ruler, she can visit other ladies of the chief ministers of the ruler. The same can be said of nuns and women of the service classes. These are all wandering spies.

Among these spies, those who belong to high families and are loyal, trustworthy and trained to assume disguises, suiting

different countries and professions, knowing several languages and arts, should be deputed by the ruler, to spy in his own country on the movements of his administrators, priests, army men, the next to authority, the watch and ward men, officers of the palace, the controller of revenues, the body guards, the commissioner, the municipal officers, the superintendents of government business, the inspector of factories, the councillors, heads of departments, the chief commissioner and officers incharge of defence, boundaries and border areas.

Special spies, who do security work for the ruler, like carrying his standard, managing throne, his household affairs including his wardrobe, attending his state carriage and other conveyances should spy on the overt doings of these officers.

Social spies should convey such information gathered from the special spies to the bureaus of espionage or intelligence.

Poisoners such as sauce makers, chefs, bathroom attendants, masseurs, bed-room attenders, toilet specialists, servants with bodily deformity, dwarfs, the dumb and the deaf, idiot and blind, professionals like actors, dancers, musicians, vocalists, comedians, poets as well as women, should spy on the private character of these officers.

A mendicant woman should carry such information to the bureau of espionage or intelligence.

The concerned officers of the bureau of espionage should, by making use of symbols and writing, charge or commission their own spies to check up such information.

Neither the bureaus of espionage nor the wandering spies should know each other.

If any mendicant spy is held up at the entrance, the door keepers, spies disguised as parents or relatives, women artisans, bards or courtesans should, under pretext of professional practices, or through concealed writing, or by symbols, carry information of their presence to the proper quarters.

When information thus received is confirmed by all these sources, it is held proved. If the information is false, the spies concerned should be punished in secret or dismissed.

Some of these spies receive their salaries from the ruler's rurse specially if they stay with him (or from the foreign rulers

if they are with them) but when they help to capture robbers. of two states, they receive salaries from both the states.

Those spies whose children and family are kept as hostages,. should receive salaries from both the states and are to be considered as missioned spies. Their worthiness is to be tested. by professional experts.

Thus, spies should be instituted to cover rulers who are enemies, friendly or neutral, of lower status, or natural, and to cover the several departments of administration.

Hunchedbacks, dwarfs, eunuchs, ladies of attainment, the dumb and various grades of foreigners should be spies in their own homes.

Trader spies stationed in a country or fort, priests and ascetics outside in the suburbs, the farmer and the saint in the rural parts, herdsmen in the frontier areas, forest tribes in the forest areas, wild tribesmen in the borders should be charged with watching the movements of the enemies. All these should promptly send reports of their work.

Foreign spies should be discovered by local spies. The bureau of spies should set spies in the task.

Those chiefs whose designs are inimical, and are found out by the spies of the ruler, should be made to live on the frontiers of the state.

Chapter 12

HOME AND OPPOSITION PARTIES

HAVING instituted spies over his chief officers, the ruler should spread his intelligence net-work over the citizens and the country folks.

Social spies, forming into opposite camps should carry propaganda in place of confluence of people, tourist centre, associations and general congregations.

One spy will say: "Our ruler is blessed with all merits. He does not oppress people either in the town or in the country by heavy taxes and fines."

Another may contest the first speaker and say: "People afflicted by anarchy, as in the fable of the fishes, first elected their ruler allotting him one/sixth of grains and one/tenth of trade and commerce for his royal dues. Sustained by this payment, rulers assumed the responsibility of uphodling the security and safety of their subjects and for protecting them from unjust taxes, punishments and sins. Hence even saints give rulers one/sixth of grains collected by them as tribute. The ruler is the chastiser and giver of rewards. Hence whoever calls down the rulers will call down punishments on himself. The rulers should be respected."

Thus the opposing parties to the rulers should be silenced.

Spies should also know all news current in the state. Special spies should collect news of joy or distress among those who professionalise in grains, cattle and gold of the ruler, among those who supply them to the ruler (or administration); among those who harbour a relative or restrain a troubled area and those who check a wild tribe or an invading enemy. The greater the contentment of such groups of people, the greater the rewards given to them. Those who demur should be propitiated by presents or conciliation, or disputes may be created to break their alliance with each other, as from a neighbouring enemy, a wild tribe or a disputant to the ruler's position.

Failing this measure, they must be commissioned to collect unpopular fines and taxes. Those in severe opposition may be quelled by punishment in secret, or by exposing them to the wrath of the people of the land. Or having hostaged their families, they may be sent to the mines to snap contact with the enemies.

The enemies employ as instruments those who are incensed, those who are ambitious, as well as those who despise the ruler. Special spies, parading as fortune tellers, should be instituted to spy on such persons in their relation with each other and with foreigners.

Thus, in his own state, the ruler should preserve parties and factions among the people, friendly or opposed, powerful or puerile, against the intrigues and machinations of the foreigners.

Chapter 13
INFLUENCING PARTIES IN AN ENEMY STATE

In dealing with parties in the enemy state, care has to be taken of angry groups which are as follows :

Those who are deceived with promise—of large rewards; those of whom one party, though of equal skill in artistic work, is treated with disdain; those who are harassed by the rulers' party; those who are invited to be insulted; those who are treated ill with banishment; those who have failed in their professions, even with large funds; those who are deprived of their rights or of their inheritance; those who are black-listed in government service; those who are despised by their kinsmen; those whose women are insulted; those who are clapped in jail; those who are punished in camera; those who are warned of their misdeeds; those whose properties are forfeited; those who have suffered from long-term imprisonment; those whose relatives are banished.

There are also groups who live in alarm:

He who is dogged by misfortune created by himself; he who is insulted by the king, he whose sins are exposed; he who is scared by punishment meted out to a person of the same guilt; he whose lands are forfeited; he whose spirit is broken down by strong measures; he who, as an officer of government, has made huge fortunes; he who, as a relative of such a person, hopes to inherit his riches; he who is despised by the ruler.

These are ambitious or greedy persons:

He who is impoverished; he who has ruined himself; he who is miserly; he who is a victim to evil practices; he who is engaged in risky transactions.

These are proud persons:

He who lives unto himself; he who is greedy for honour, he who is intolerant of his rival's esteem; he who is valued low; he who has a stern spirit; he who is reckless and he who cannot live within his means.

Groups can be won over by spies working on them and saying: "This ruler is like a wild elephant. He can only be restrained

be setting up a rival ruler. Abide by your time."

Alarmed groups can be won over by the propaganda: "The present ruler is venomous. You had better migrate."

Ambitions and greedy groups can be assured, "This ruler is indiscriminate, he gives to the unworthy. He ignores bravery, learning, foresight and valour. Better have another ruler."

Haughty groups can be won over: "This ruler, low born, will only give to such persons but not to people like you. Better set up another ruler who can set matters right."

These incitable groups should form a sacred compact with spies to achieve their aim.

Similarly, friends of a foreign king can only be won over by rewards and propaganda, while impending enemies can be seduced by breaking alliances, open threats and by showing the defects of their ruler.

Chapter 14
ADMINISTRATIVE COUNCILS

AFTER consolidating the attitude of both internal and external parties, both within and abroad, the ruler should consider administrative affairs.

Deliberation in well-constituted councils precedes administrative measures. The proceedings of a council should be in camera and deliberations made top secret so that not even a bird can whisper. The ruler should be guarded against disclosure.

Whoever divulges secret deliberations should be destroyed. Such guilt can be detected by physical and attitudinal changes of ambassadors, ministers and heads.

Secrecy of proceedings in the council and guarding of officers participating in the council must be organised.

The causes of divulgence of counsels are recklessness, drink, sleep-talking and infatuation of women which assail councillors.

He of secretive nature or who is not regarded well will divulge council matters. Disclosure of council secrets is of advantage to persons other than the ruler and his high officers.

Steps should be taken to safeguard deliberations.

One ancient authority says : "The ruler himself should alone deliberate secret matters. Ministers have their own advisers and the latter have their own counsellors. This endless chain of counsellors makes secret impossible. None outside the ruler shall know what he contemplates; only those who have to administer it shall know either when it is initiated or when it is performed."

Another authority opines: "No deliberation made by a single person can be fructuous. The ruler has work which is both perceptible and imperceptible. Much has to be done by inference. All this can be done only by deliberations by ministers-in-council. Hence the ruler should sit with persons of high and wide intellect. He should hear opinions from all. Wisdom is found even in a child's sensible utterance."

A third authority observes: "This is only finding other opinions but not guarding counsels. The ruler should ask his advisers for their opinion on a work similar to what he contemplates, and he should do what they advise. If it is done this way, opinions are also gathered and secret maintained at the same time."

A fourth authority does not agree with the view: "When advisers are asked to give the opinions regarding a remote matter, or a project undertaken or a project not yet undertaken, they either approach the subject with indifference or give half-hearted views. The ruler should, therefore, consult such persons as can give conclusive opinions regarding projects on which he seeks advice. If he consults in this manner, good advice and secrecy are both ensured."

Unfortunately, this is an endless process. The ruler should consult three or four ministers. Complicated issues cannot be settled by consulting a single minister. A single minister proceeds with doggedness and without restraint. In deliberating with two, the ruler may be overpowered by their combined advice or confused by their conflict. With three or four advisers, the results will be satisfactory. If it is more, secrecy may be violated. The ruler may decide or deliberate with himself, or with one or many ministers, according to the needs of place,

time and nature of the project contemplated.

Every deliberation has five stages: means to carry out the project; control of men and resources; the location and time of work; devices against dangers and final completion.

The ruler should not tarry when the opportunity comes; nor shall he dally with those parties whom he intends to hurt.

One school of thinkers says that the advisory council should consist of twelve members. Another school says that it should consist of sixteen members. A third school argues in favour of twenty.

But the council should consist of as many members as the state shall bear. The ministers should deliberate on all matters concerning the ruler's party and that of his enemy. They should also decide on work that is to be begun, to accomplish what is begun, to improve what is accomplished and to enforce orders.

The ruler himself should supervise projects, with his officers, which are at hand and send instructions for executing those which are far away.

In times of emergency, he should summon both his ministers and the council of ministers and report to them. He should abide by the majority decision which shall carry him to success. And keep his projects a secret from others, but he shall know the weakness of his adversaries.

Chapter 15

DIPLOMATIC PERSONNEL

WHOEVER has succeeded as a member of the administrative council can be an ambassador.

A senior administrative officer can carry a commission.

Whoever has half of the above standing can be charged with a distinct mission.

He who has half of the above qualifications can be a conveyor of orders.

An ambassador, having arranged for carriage, conveyance, attendents, and stay should consider the mission entrusted to him in all its different aspects.

He should make contacts with the enemy's counterparts and officers connected with frontier tracts, interior of the country and of the cities. He should compare military stations, war-potential and fortresses of the enemy with those of his own country. He should also ascertain the depth of defence, the strongholds of the treasury and the pregnable and impregnable points of the enemy.

Having sought leave to enter the capital of the enemy, the ambassador should state the object of his visit as exactly as he is commissioned, even at the risk of his own life.

These should be taken as indications of the enemy's good disposition-towards the ambassador and, the reverse, his displeasure:

Delight in the voice, face and eyes of the receptionist, courtesy in demeanour, solicitude about friends, offering a prominent seat, friendly memories, indicate satisfactory conclusion of mission.

An incensed enemy may be addressed: "Ambassadors are only representatives of rulers, not only of yourself, but of all. They have to present their mission as they are instructed, even in the face of displeasure. They do not deserve punishment for doing their duty." Such speech is the duty of ambassadors.

The envoy should stay without any elation at the respect shown to him, till he is allowed leave to depart. He should not care for the opulence of the enemy. He should strictly avoid damsels and dope. He should sleep single. The real intention of ambassadors is divulged whether in sleep or under drink.

The ambassador should ascertain, through the agency of the intelligence service receiving salary from both the states, the character of favourable party intrigues, as well as unfavourable party manoeuvres and assess loyalty inspired by the enemy in his own country.

If no direct contacts can be built for such intelligence, the envoy should gather it by observing people around him in all walks of life and in all sorts of places and by employing secret signs and symbols. These he should test and verify.

He should not interrupt the enemy's estimate of his own ruler or even assert. He should dismiss such attempts with the formula, "You know all."

If the envoy is detained without conclusion of his mission, he must interpret his detention as implying: that the enemy sees danger to his own ruler and himself and wishes to avert it; that he contemplates diverting an enemy to his own ruler or another ruler whose state is separated by other buffer states; that he is engineering a rebellion against his ruler either internally or through a wild ruler; that he is seeking a fresh alliance with a state contiguous to his own ruler's; that he is quelling or preventing an internal upheaval or external invasion of his own territory; that he is delaying invasionary expedition from the ruler concerned; that he is piling belligerent stores, or strengthening fortifications or raising fighting forces; that he is abiding fuller training of his armed forces; that he is forging a powerful alliance to face the contempt proferred.

Then the ambassador may decide to stay or to depart as he considers desirable or demand a speedy conclusion of his mission. An ambassador's duties consist of: discharge of commissions, preservation of treaties, communication of ultimata, forging of alliances, engineering intrigues, breaking of alliances among blocs, organising secret armies, smuggling of relations and gems, gathering intelligence about espionage, display of strength, violation of treaties of peace, seduction of envoys and officers of the enemy.

Chapter 16

PROTECTION OF PRINCES

THE ruler should take care of himself from attacks from enemies, queens and the princes.

An ancient thinker says: "Princes like crabs, consume their own progenitors. When they show such tendency, they should be secretly punished."

"Such," says another, "may lead to extinction of ruling dynasties. It is better to keep them under guard in a determined place."

"Such a procedure," says a third, "is like snake-scare. It may make the prince feel superior and attack his own father.

"Hence it is better to keep the prince under frontier guards or in a fortress."

"This," says a fourth, "is like scare from a wolf in the midst of a pack of sheep. The son may form alliances with his guards and rebel. It is better to banish him abroad."

"This," says a fifth, "may lead to exploitation of the prince by foreign powers. He should be made to live with his maternal relations."

"This," says a sixth, "may lead to misuse of the prince by the relations in dissipation."

This is the worst remedy, since it leads to the ultimate destruction of the ruler's family. All care should be taken to bring up the prince well. When the prince attains the age of puberty, experts should train him under proper discipline.

Any of the special spies may lead the prince, say some authorities, to infatuation towards hunting, gambling, drinking or woman and instigate him to rebel against his own father.

The prince should be protected from wicked influences. He should be taught properly, since he is at an age of trust. He should be told about right, but not of non-right; he should be told of wealth, but not of non-wealth. He should be scared of drink and women by a process of making him drunk and of confronting him with blackmailing women. If fond of gambling, he should be blackmailed by tricksters. If fond of hunting, by forest brigands. If he shows proclivities for rebelling, he should be scared by narration of hardships and even ignominious death attending such ventures.

When a prince is of commendable disposition, he should be made commander-in-chief or nominated successor.

Princes are of three categories: those of dynamic intelligence; those of stagnant intelligence; and those who are perverts.

He who carries out mandates of right and leading to wealth is of dynamic intelligence. He who never carries out good instructions is of stagnant intelligence. He who entangles himself in avoidable dangers leading to wickedness and poverty is a pervert.

If a ruler has a perverted son, attempt should be made to beget a grandson by him. Or to get sons from his daughters.

If a ruler is too old or deceased to beget children, he may

mandate a close relation or any neighbouring ruler of high qualities to beget a son for him through his queen.

Never should a pervert son be made to sit on the seat of power.

Unless in times of grave danger, the eldest son should succeed the ruler. Sometimes sovereignty may reside in a corporation. Corporate sovereignty is the most invincible form of authority in the world.

Chapter 17
PRINCES UNDER RESTRAINT

THOUGH a prince be employed in a task which is difficult or infra dig, he must obey his father, unless the performances of the task endangers his life, incites the people or creates calamities. In a good work, he should win the good graces of his employer, make it supremely successful and share the profit with his father. If his father is still not pleased with him, he may seek permission for self-banishment.

If imprisonment or life danger threatens him in his father's state, the prince should migrate to a neighbouring state which is better ruled and be hospitable to him. There he should collect men and materials, make marriage alliances with powerful persons and consolidate his contact with fighting tribes. He should win parties over in his own state.

Or migrating alone, he may practice a profession in precious mines or in high commerce. Or amass wealth by strategy among rich widows, merchants, engage in world trade, or acquire religious wealth. He should abstain from wealth of the intellectuals. He may practise strategy to conquer foreign villages. Or he may rebel against his father with help from his mother's people.

Or he may under disguise as painter, carpenter, jester, poet, physician or heretic with his retinue similarly disguised, present himself before his father and offer him challenge.

Reconciliation between the ruler and his offspring may be effected by an espionage force or by the mother. An abandoned

prince may be destroyed with weapons or poison. If not
abandoned, he may be captured with woman or wine or by
ruse and restored. A restored prince may either be reconciled
or, if there are other princes, banished.

Chapter 18
THE RULER'S DAY

AN energetic ruler will keep the people equally energetic. A
slopper will not only make people lazy, but will be consumed
by his enemies. The ruler should always be alert.

The ruler's day should be divided into eight sectors of day
and eight sectors of night. There will be four sectors in the
forenoon and four in the afternoon. Similarly at night.

In the first sector of the day, the ruler should inspect guards
and supervise accounts. In the second, he should attend to
public affairs. In the third, he should attend to his own toilet
and study. In the fourth he should consider appointments.
In the fifth, he should correspond and receive information. In
the sixth, he may retire into amusements or study. In the
seventh he should inspect his forces. In the eighth, he should
confer with chiefs of defence forces. At the close of day, he
should engage in evening prayers.

In the night, in the first sector, he should receive secret
missions. In the second, he should attend to his supper and
study. In the third, he should retire to his bed chamber. In
the sixth he should be awake, after slumber, and inspect his
next day's engagements. In the seventh he should deliberate
on administrative problems and instruct the intelligence service.
In the eighth sector, he should confer with his advisers, spiritual,
and temporal, and get into his public chamber.

He may make suitable alterations in the above time table.

In his public chamber or audience hall, the ruler should
never make any petitioners wait at the door. He should him-
self attend to petitioners and not depute any of his officers. He
should personally attend to affairs relating to religion, to the
elite, to resources, to consecrated places, to minors, to the aged,

to the afflicted, to the resourceless and to women. He should vary the precedence to suit emergencies.

In the happiness of his subjects is the ruler's prosperity. Whatever pleases his subjects, is to be taken by the ruler as his good. He must strive towards this end.

Chapter 19
ROYAL CHAMBERS

ON a suitable site, the ruler should construct his residential chambers, enclosed by a fort and a moat and provided with one major entrance.

His own palace should be as strongly constructed as his treasury-chambers. Or he may have his own home in the midst of his love-chambers. There should be secret passages built into the walls for personal safety. If the chamber is on stairs, it should be provided with secret stairs and concealed exits built into pillars. Mechanical devices capable of collapsing the building in an emergency should also be provided.

The ladies' chambers must be made fire proof both with the intelligence of man and with fire proof construction material. It should be rendered poison and snake proof also.

One of the chambers, in the rear of the ladies' palace, should contain all useful medicines for midwifery and diseases. There must be a pond also. The princes' chambers should be planned outside these chambers. Outside these, the beauty-parlours, the advice-chambers, the audience halls and the offices of the princes and of personal officers.

In the places between the two, should be posted the guard of the palaces of the ruler and his family.

In his ladies' chambers, the ruler should see the queen only when she is ready to receive him. He should keep his ladies away from the evil influences of ascetics, comedians and dubious female companions; and even society women.

Celebrated beauties, with clean habits, should be allowed into the ladies' chambers. Veteran men and women should be placed in charge of the ladies' chamber and their inmates.

Outside influences should be carefully controlled.

Traffic in commodities from and to the ladies' chambers should be carefully guarded and regulated under seal.

Chapter 20

PERSONAL SECURITY

On arising from his bed, the king should be received by a contigent of armed maids-in waiting. In the second chamber, he should be received by his personal valets, veterans of the household and other attendants. In the third, he should be met by his miscellaneous personal staff and in the fourth, by his chief advisers and security staff.

The ruler should employ as his security staff, only such persons as have noble and proven ancestry and are closely related to him and are well trained and loyal. No foreigners, or anonymous persons, or persons with clouded antecedents are to be employed as security staff for the ruler.

In a securely guarded chamber, the chief should supervise the ruler's food arrangements.

Special precautions are to be taken against contaminated and poisoned food. The following reveal poison: rice sending out deep blue vapour; unnaturally coloured and artificially dried-up and hard vegetables; unusually bright and dull vessels; foamy vessels; streaky soups, milk and liquor; white streaked honey; strange-tempered food; carpets and curtains stained with dark spots and thread bare; polishless and lustreless metallic vessels and gems.

The poisoner reveals himself by parched and dry mouth, hesitating talk, perspiration, tremour, yawning, evasive demeanour and nervous behaviour.

Experts in poison detection should be in attendence of the ruler. The physicians attending the ruler should satisfy themselves personally of the purity of the drugs which they administer to the ruler. The same precaution is indicated for liquor and beverages which the ruler uses. Scrupulous cleanliness should be insisted on persons in charge of the ruler's dresses and toilet

requisites. This should be ensured by seals.

Charming maids should be employed as bathing assistants, masseuses, chamber maids, laundry attendants, flower girls and should be held responsible for the purity of the toilet requisites used by the ruler.

In any entertainment meant for the amusement of the ruler, the actors should not use weapons, fire and poison. Musical instruments and accoutrements for horses, elephants and vehicles should be secured in the palace. The ruler should mount beasts and vehicles only after the traditional rider or driver has done so. If he has to travel in a boat, the pilot should be trustworthy and the boat itself secured to another boat. There should be a proper convoy on land or water guarding the ruler. He should swim only in rivers which are freed of larger fishes and crocodiles and hunt in forests free from snakes, man-eaters and brigands.

He should give private audience only attended by his security guards. He should receive foreign ambassadors in his full ministerial council. While reviewing his militia, the ruler should also attend in full battle uniform and be on horse back or on the back of an elephant. When he enters or exits from the capital city, the path of the ruler should be guarded by staffed officers and cleared of armed men, mendicants and the suspicious. He should attend public performances, festivals, processions or religious gatherings accompanied by trained body guards. The ruler should guard his own person with the same care with which he secures the safety of those around him through espionage arrangements.

Chapter 21

BUILDING OF VILLAGES

THE ruler may form villages either on new sites or on old sites, either by shifting population from heavily populated areas in his own state or by setting population immigrating into his state.

Villages should consist of not less than a hundred and not more than five hundred families of cultivators of service classes. The villages should extend up to about one and a half mile or three miles each and should be capable of defending each other. Village boundaries may consist of rivers, hills, forests, hedges, caves, bridges and trees.

Each eight hundred villages should have a major fort. There should be a capital city for every four hundred villages; a market town for every two hundred villages and an urban cluster for every ten villages.

The frontiers of the state should have fortifications protected by internal guards, manning the entrances to the state. The interior of the state should be guarded by huntsmen, armed guards, forest tribes, fierce tribes and frontier men.

Those who do social service by sacrifices, the clergy and the intellectuals should be settled in the villages on tax free farms.

Officers, scribes, cattlemen, guards, cattle doctors, physicians, horse-trainers and news purveyors should be given life interest in lands.

Lands fit for cultivation should be given to tenants only for life. Land prepared for cultivation by tenants should not be taken away from them.

Lands not cultivated by the landholders may be confiscated and given to cultivators. Or they may be cultivated through hired labourers or traders to avoid loss to the state. If cultivators pay their taxes promptly, they may be supplied with grains, cattle and money.

The ruler should give to cultivators only such farms and con- c ssions as will replenish the treasury and avoid denuding it.

A denuded exchequer is a grave threat to the security of the state. Only on rare occasions like settlement of new areas or in grave emergencies should tax-remissions be granted. The ruler should be benevolent to those who have conquered the crisis by remission of taxes.

He should facilitate mining operations. He should encourage manufacturers. He should help exploitation of forest wealth. He should provide amenities for cattle breeding and commerce. He should construct highways both on land and on water. He should plan markets.

He should build bunds, filled with water either perennial or from other sources. He should assist those who build reservoirs with resources and communications. Similarly, in construction works of communal comfort and public parks.

All should share in corporate work, sharing the expenditure but not claiming profit.

The ruler should have suzerainty over all fishing, transport and grain trade, reservoir and bridges.

Those who do not recognise the rights of their servants, hirelings and relatives should be made to do so.

The ruler should maintain adolescents, the aged, the diseased and the orphans. He should also provide livelihood to forlorn women with prenatal care and protection for the children born to them.

Veterans of the village should improve the property of orphaned minors till they attain their majority. So also the property of the shrines.

When an earning person—man or woman—fails to maintain his or her child, wife, mother, father, minor brothers, sisters or young widows, he or she should be punished with fine.

Similarly no man shall become an ascetic without making provision for the sustenance of his dependents. So, too, a person who attempts to seduce women into ascetism renders himself liable to punishment.

The villages are out of bounds for any but forest-resident ascetics, local finance companies and local corporate guilds. There shall be no actors, musicians, drummers, orators or poets sponging on the resources, labour and drinks of the villagers.

Villagers live on their fields.

The ruler should abstain from taking over any area which is open to attack by enemies and wild tribes and which is visited by frequent famines and pests. He should also abstain from extravagant sports.

He should protect cultivation from heavy taxes, slave labour and severe penalties, herds of cattle from cattle lifters, wild animals, venomous creatures and diseases.

He should clear highways of the visitation of petty officials, workmen, brigands and guards. He should not only conserve existing forests, buildings and mines, but also develop new ones.

Chapter 22

LAND CLASSIFICATION

ON uncultivable lands, the ruler should plan pastures. The pious should be given plantation ground for sacrificial wine and for their monasteries and penance. Such forest areas, made secure for men and beasts, should be named after the school to which the group belongs.

The royal hunting forest should be as extensive as possible with only one inlet and mostly planted with juicy fruit orchards fragrant bushes, bowers and shrubs, inlaid with ponds. It should contain animals rendered harmless like tigers and carnivora without claws and teeth, cow elephants and calf elephants, bisons—all intended for the ruler's sport.

At one extreme of the state or in any other suitable locality, there should be another public game forest, open to all, filled with game. Reserved forests capable of yielding forest products should also be conserved. Factories for the processing of forest products and forests yielding such products should also be planned. In one extreme of the state, dense elephant forests, distinct from wild tracts, should be preserved.

The officer of elephant forests with his forces of guards should not only conserve the forests but also possess knowledge of all entrances and exists to forests which are hilly or bossy or filled with swamps and rivers.

Whoever kills an elephant shall forfeit his life.

Whoever brings in the tusks of an elephant, after its natural death, shall receive suitable rewards.

Elephant forest guards, with the assistance of elephant breeders, elephant chainers, boundary-guards, forest folks, elephant nurses and five or seven cow elephants to capture and tame wild ones, should trace the locale of wild elephants through their excreta and their other habitual tracks. They should also determine whether the tracks are those of herds, rogues, stray elephants, tuskers, young elephants or tame ones.

Elephant capturers should follow the instructions given by elephant experts and capture elephants possessing good and auspicious traits. Elephants are vital in the life of rulers. They should have large frame, be ferocious to destroy enemy armies, to dismantle fortifications and encampments and capable of dangerous tasks. Elephants captured in certain localities have natural graces, but the strength and skill of all elephants can be improved by suitable training.

Chapter 23
FORTIFICATIONS

WARTIME defensive fortifications should be constructed on all the four boundaries of the state, depending on the special features of the terrain. In riverine tracts, riverine fortifications consisting of island fortresses; in plains, a ground encircled by lowlands, in hills, cave and rock fortifications; in desert, dry and thorny fortifications; in forests, swampy thorny and bush fortifications.

To defend populous areas, the best fortifications are watery and rock fortifications ; in wild areas, desert and forest fortifications should be constructed.

The ruler should have his war exchequer in his prime capital situated in the centre of the state. This should be located in banks or confluence of rivers, or a deep lake with a circular fortress or rectangular or square fort, skirted by an artificial moat and drawbridges.

Around this fort twice parallelled trenches, separated from each other by six feet of ground, filled with water and crocodiles and lilies should be laid out. A rampart thirty-six feet high and seventy-two feet broad should be built with a square footpath and planted with thorns.

The pathway for vehicles should be constructed out of stone slabs and cobbles. Towers also should be built. So also entrances and exits for the ramparts. Outside the ramparts obstructions can also be built in. Similarly, turrets, parapets with strong protective devices should also be planned.

Chapter 24
FORT BUILDINGS

THREE royal roads should fork out from west to east within the fort, and three more from south to north.

The fort should have twelve entrances, all protected with defensive devices and escape exists.

Vehicle roads, procession roads, roads to other towns, capital roads, village roads and roads to pastures should be twenty-four feet wide. Roads leading to cross-roads, cantonments and cremation grounds should be forty-eight feet wide.

Gardens roads, grove paths and forest paths should be twenty-four feet.

Elephant paths should be twelve feet.

Palaces should be built on strong grounds in the centre of the community and northward to the centre of the fort, facing either east or north. These should be spread over one/nineth of the entire inside areas of the fort.

Royal preceptors, priests, temples, ponds and counsellors should occupy sites east by north to the palaces of the ruler.

On the eastern sites, perfume merchants, flower merchants, provision dealers, artisans and fighting personnel should have their abodes.

South by east should be located the exchequer, the accounts offices and factories.

Forest stores and arsenal should be on sites south by west.

To the south, the city fathers, leaders of commerce, of factories and officers of the armed forces, restauranters, wine-merchants, meat vendors, courtesans, entertainers and trading classes should live.

To the west by south cattle stables and work houses; to the west by north chariot garages and horse stables. To the west, weavers, yarn merchants, mat-workers, skin workers, armour-makers, weapon forgers, glove makers and service class should dwell.

North by west, shops and hospitals, should be located.

North by east, the treasury, dairy and horses. In the north should be installed the royal shrine. The ironsmiths, jewellers and the priestly classes.

Guilds should be scattered in the several corners of the city along with workmen's quarters.

Either to the north or to the east of the city, burial and cremational grounds should be situated. Outcastes should live beyond the burial grounds.

Workmen should be provided with quarters near their places of work. Their families should have gardens and fields allotted to them.

Every ten houses should have a drinking well, stores of oils, grain, sugar, salt, medicines, vegetables, green and dry, grass, dried meat, hay, firewood, metals, leather, charcoal, guts, poison, horns, bamboo, cloth, wood, weapons, armour and stones should be built to last for years. Old stores should be replaced with new ones when acquired.

Many officers for elephants, cavalry, chariots and infantry should be appointed to maintain integrity of staff. So too with regard to frontier guards and fortification workers. Elements dangerous to security should not be let into the forts.

Chapter 25

THE ROYAL HOUSEKEEPER

THE royal housekeeper should supervise the construction of a

treasury chamber, trading house, grain store, forest produce store, the armoury and the jail.

He should cause a square well to be sunk up to water level and have it paved with stones on the bottom and the sides. He should construct in that well an underground chamber of strong timber—three storeys high—the top most of the storeys being at ground level. The central plan should have the floors plastered with stone and a single door, and be provided with moveable stair-case.

Above this chamber, the treasury chamber should be constructed with bricks and with roofs and opening into the general store house.

He may have a palatial treasure house constructed in any secure part of the state, to hold the central treasure of the ruler against dangers and calamities. The trading house should consist of an enclosed quadrangle with buildings on four sides and with a single door.

The store house should have many spacious rooms and enclose forest store house and be connected with the armoury and the underground chamber.

The court of justice and the administrative officers should be located in a separate site.

The jail should contain separate sectors for men and women and sufficiently guarded.

All these buildings should be provided with assembly halls, toilets, water-tanks, bathrooms, fire and poison protections. The store house should have a rain-guage installed in front.

The housekeeper, assisted by experts, should supervise receipt of gems and raw materials of different values. He should receive only genuine gold coins certified by experts. Counterfeit currency should be cut up. Those who purvey counterfeit coins should be punished. Pure and fresh grains should be received in full measure. Short measures should be punished with penalties up to thrice the value of the grains traded. The same rule should apply to other merchandise. The housekeeper should attend to the work of revenue-collection assisted by trusted officers.

Chapter 26
COLLECTION OF REVENUE

THE collector collects dues from forts, other areas of the state and mines, buildings, and bridges, forests, settlements and commercial routes.

Dues from urban areas or forts comprise : tolls, fines, taxes on weights and measures, urban dues, dues from coinage, from seals and passports, from warehouses, from courtesans, from gambling, from selling sites, from work and engineering guilds and from immigrants.

Dues from other areas include produce from cultivated lands, government dues from farming lands, sacrificial dues, money taxes, dues from merchants, river-taxes, fees for ferries, dues from ships and boats, levy from towns, pasture levies, road cesses, taxes on land and prison taxes.

Dues from mines cover those from gold, silver, diamonds, precious stones, pearls, corals, ocean products, metals, salt and other minerals.

Dues from buildings and bridges bracket those from flower-gardens, orchards, vegetable gardens, wet fields and seed-gardens.

Dues from forests are derived from game forests, timber forests and elephant forests.

Dues from settlements come from cattle-settlements, goats, sheep, asses, camels, horses and mules.

Dues from commercial routes arise from land and waterways. All these form the receipt structure.

Several forms of receipt can be distinguished: capital receipts, share receipts, interest receipts, fine receipts, licenses, profits on coinage, penalties.

The structure of expenditure consists of:

Ceremonial expenditure on shrines and ancestors, gifts and endowments, domestic expenditure, intelligence service, stores, armaments, warehousing, stock filling, manufacturing, labour maintenance, defence expenditure, cattle farming, maintenance of museum, bird and beast sanctuaries and sustenance stores.

The collector should pay attention to the collections done, the collections accomplished, the residue of collections done, receipts,

expenditure and the balance to be recovered.

The "collections" include: the task of administration, the routine executive work, the collection of necessary resources and the control and audit of receipts.

The collections made includes: that which has been credited to the exchequer, that which has been drawn by the ruler, that which has been spent for administration but not entered in the records or carried from the previous year or which is in the process of being entered.

The residue of collections includes plans for profitable work, unrealised fines, receipt kept in abeyance and scrutiny of accounts:

Receipts may be (i) recurring, (ii) arrears and (iii) windfall. Recurring is what is recived from day to day. Arrears are what have been carried from last year, whatever is not yet realised and whatever has changed hands. Windfalls cover: whatever has been lost and forgotten, fines realised from Government servants, residual revenues, damages for injuries, royal tributes, properties bequeathed to the state and treasure troves.

Means to control expenditure are: investment of funds, the balance of losses and savings from estimated outlay.

Profits arise from: rise in price of goods created by different weights and measures which creates premium and rise of price due to competition among buyers, which creates profit.

Expenditure is of two kinds: daily which is current and profitable expenditure which arises over period of time: a fortnight, a month and a year.

That which is residual after the expenditure incurred, and excluding all receipts to be realised is not balance, which may have either been struck or brought forward.

The collector should be vigilant in increasing the income and controlling expenditure.

Chapter 27
MAINTENANCE OF ACCOUNTS

IN the accountant's office, constructed facing north or east, the controller of accounts should plan out seats for the accounts

clerks and shelves for placing the account books.

Separate registers should be kept for : the record of operation and results of factories, the profits made and the losses incurred; expenditure involved, earnings deferred, premia and interest affected, the nature of government agency involved, wages paid, the number of labourers—free—employed in relation to investments made. In relation to precious metals and other stores, the value of each category, the barter rates of exchange, the counter weights used, their number weight and cubic measure, similarly, the history of customs, professions and trade of countries, villages, families and traders companies. So too assets of the royal ladies and princes in precious metals, lands, prerogatives and provisions enjoyed by them. Treaties, ultimata and tributes relating to foreign states, friendly or hostile. All should be shown in separate registers kept.

These books form the base for the controller's report detailed in the earlier section.

To oversee different kinds of work—superior, medium and low category—suitably qualified overseers should be employed. The rules will incur losses if expenditure on profitable works is, for any reason, reduced.

When a person in the employment of the state absents himself, his collateral sureties or his sons, brothers, wives or daughters who are beneficiaries of his wages should make good the loss incurred by the government in his absence.

The working year consists of three hundred and fifty four days and nights. The work done by any person is paid wages in proportion to the quantity in the middle of July every year on calculation of average work turned out.

An officer of the government, negligent of the intelligence supplied by the espionage system and failing to observe regulations governing business in his own department, may expose the government to loss of revenue. Such losses may occur due to ignorance of the officer, or to his indolence and weakness or to his debility in hearing, sight or in other senses of perception, or to his timidity to face opposition, threat or troublous consequences, or to his selfish gains affecting efficient performances of duty, or to proclivity to cruelty generated by anger, or to lack

of official dignity displayed when surrounded by learned and greedy sycophants or to dishonesty by the use of false balance, wrong measures and fraudulent calculations to serve his own selfish ends.

One school of jurists holds that a penalty calculated by multiplying the loss of revenue by the serial number of the circumstances of the guilt enumerated above should be imposed on the officer involved.

Another school says that the fine in all cases should be eight-times the revenue lost by such negligence or fraud. A third school puts the penalty at ten times the loss incurred A fourth school opines that it should be twenty times of the loss.

The present author is of the view that the penalty imposed should be proportionate to the guilt of the officer concerned. All accounts should be reported in the month of July.

When accountants from the different district present their sealed statements of commodities and revenue receipts and expenditure, they should be kept segregated to prevent accounting conspiracies. The net amount for each should be received after tally of accounts.

The head of department should be rewarded eight times the amount of increase in total revenue effected either by increase of revenue of his department or by decrease of expenditure shown. Similarly if the department shows loss, penalty to the same extent should be imposed on the person involved.

Those officers, who do not submit their accounting statements in time or fail to produce their statements along with their net revenues, should be fined ten times the amount due from them.

When an accounts officer does not check and receive accounts when his clerks are ready with them, he should be suitably punished. When the clerks default, they should be punished severely.

All the ministers should submit the accounts relating to their departments together. Any minister who does not comply with this or gives a false statement should be punished most severely.

When an accounts officer has not prepared his daily statement, he may be given a month for preparing it. After that period daily fine may be imposed on him prorata for the days he delays

submission of the accounts.

Accounts so submitted along with the net revenue received should be checked against correct procedures and precedents and accounting practices involving addition, subtraction, inference and enquiry; and also with reference to the period of time involved.

The annual statement of accounts also should be verified with reference to the place and time involved, the nature and head of collection, the ratio of present to past realisation, the person paying it, the officer causing the realisation and the officer who received it. The expenditure statement should also be verified for profits from any source, the place and time for each source, the amount paid, the officer ordering collection, the officer remitting it, the official delivering it and the official finally receiving it. Similar statements should be prepared relating to net revenues.

When an officer fails to facilitate receipts and expenditure prescribed or prevents execution of orders he shall be suitably penalised. Any clerk who does not conform to prescribed forms of accounting or enters what is unknown to him or duplicates or triplicates entries, he should be fined. He who erases the net total should be severely punished. He who misappropriates receipts should be fined eight times the amount involved. He who causes loss of revenue should normally pay penalty of five times the amount lost but also cover the loss. An officer making a false statement should be punished as for theft. A false entry or late entry should bear double the above punishment.

Similar recognition for efficient work and discretionary punishment for trifling errors should be awarded by the ruler.

Chapter 28

EMBEZZLEMENT BY OFFICERS

EXCHEQUER is the basis of all administration. Thus the treasury merits special vigilance.

Prosperity in finance stems from: prosperity of general activities, reward for enterprise, suppression of crimes, economy in

administration, prosperity of harvest, growth of trade, conquest of adversity and crisis, reduction of tax-remissions, inflow of precious metals.

Depletion in finance is created by: barriers to activity, investment, transactions in finance, account cooking, leakage of income, extravagance, exchange and defalcation.

Barriers are created by default in floating an undertaking or in conserving the output, or in crediting the profits. In such cases, ten times the loss should be the penalty.

Investment is made by lending the money from the exchequer.

Transaction in finance are involved in using exchequer funds for private trading and commercial purposes.

These two acts should be punished with a penalty of twice the profits, made.

He who manipulates the time for collection of revenue fabricates accounts. He should be fined five times the amount involved. He who deliberately reduces a fixed revenue or inflates expenditure is guilty of creating loss of revenue. He should be made to pay a penalty of four times the loss.

He who spends state funds in personal extravagance or in bribing others is guilty of extravagance. Here capital punishment is deserved where gems are concerned and lesser punishment where other articles are concerned. The articles enjoyed should, in addition be restored or a fine equal to their value realised.

The act of exchanging state properties for other articles is exchange. The punishment for the offences should be the same as for extravagance.

He who does not give to the exchequer the revenue collected, or does not spend what is ordered as expenditure, or misrepresents the amount collected is guilty of defalcation of state funds. He should be punished with a fine of twelve times the amount involved.

There are about forty ways of embezzlement:

What is collected earlier is credited later;
What is realised later is credited earlier;
What ought to be collected is not collected;

What cannot be collected is shown as collected;

What is collected is shown as not collected;

What has not been collected is shown as collected;

What is collected in part is shown as collected in full;

What is collected in full is shown as collected in part;

What is collected under one head is shown as collected under different head;

What is realised from one source is shown as realised from another source;

What is payable is not paid;

What is non-payable is paid;

What is payable is not paid in time;

What is payable is paid untimely (early or later);

What is a small gift is made to appear large;

What is a gift of one sort is shown as gift of another sort;

What is gift for one person is made a gift for a different person;

What is entered into the exchequer is whisked away;

What has not been credited is shown as credited;

What raw materials are not paid for are entered;

Those that are paid for are not entered;

An aggregate revenue is shown split up;

Split up revenues are shown as aggregate;

Goods of higher value are exchanged for goods of smaller value;

Goods of smaller value are exchanged for goods of higher value;

Values of goods are inflated;

Values of goods are deflated;

Number of rights are increased;

Number of rights are decreased;

Discrepancy of years and months;

Discrepancy of months and days;

Discrepancy in transactions carried under personal supervision;

Misposting of sources of income;

Wrong tally of gifts made;

Wrong tally of work turned out;

Inconsistency in representing fixed items;

Misrecording of test marks and standards of fineness of gold

and silver;
Use of false weights and measures;
Fraud in counting articles;
Fraud in cubic measures and divisions.

In cases of fraud, the involved officers like the purser, the adviser, the retainer, the teller, the officer ordering payment, the clerical staff of the officer should all be separately examined. If any of these perjure, they should be punished in the same manner as the main culprit.

A public pronouncement inviting people who have suffered by the fraud should be issued and compensation for the losses sustained arranged for them.

When a state officer is involved in several cases and is unable to establish his bonafides, he should be punished for all the offences. If an officer has misappropriated a half of the funds, he should be held responsible for the entire amount.

Any informer who supplies proven information about embezzlement should be rewarded by one-sixth of the sum involved, if not a state servant, and, if one, by one-twelfth the sum. If an informer proves even a part of the embezzlement, he should be proportionately rewarded. An unsuccessful informer should be suitably punished. An informer withdrawing his claim at the instance of the involved officer should be awarded capital punishment.

Chapter 29
GOVERNMENT SERVANTS

THOSE who have administrative qualifications should, according to individual merit, be posted as principal officers of state departments. They should be constantly kept under vigilance in their duties, as men are, by nature, fickle and temperamental. Proper assessment, must always be made, of the procedure and method, the venue and time schedule, precise pattern, expenditure and result which they employ in carrying on their administrative duties.

They should perform their state duties without either dispute or unity among themselves, as directed.

When in unity they consume state revenues.

When in discord they damage the work.

Except with regard to remedial action in emergencies, they should do nothing without knowledge of their officer.

The officer who brings in as much as or much more than the fixed amount of revenue should be rewarded with advancement and honours.

He who reduces the revenue consumes state wealth. If the reduction is bonafide, the officer should be caused to make it up.

The officer who doubles the revenue consumes the vitality of the nation. Such an officer should be suitably punished. The officer who spends the revenue in fruitless ventures consumes the labour of artisans. He should be punished proportionately to the value of work involved, the number of days spent, the amount of investment made and the wages expended.

The head of each department should carefully inspect the amount of departmental work, revenues collected and expenditure incurred both in detail and in the aggregate. He should also control extravagance, parsimony and exhibitionism.

He who consumes his ancestral capital, without cause, is an extravagant man.

He who consumes all his earnings is an exhibitionist.

He who hoards money causing misery to himself and his dependents is skin-flint.

If any of the above three categories of people is supported by a strong party, he should not be disturbed, if he has none, he should be properly dealt with.

A miser, who with immense resources, hoards in his own house or deposits money with his fellow citizens or people or invests in foreign lands should be investigated into through spies thoroughly with regard to his advisers, contacts, assistants, relatives, partners, his income and expenditure. The person who conducts his agency in foreign lands should be induced to divulge his affairs. When the inquiry is completed, the miser should be liquidated discreetly.

The administrators of all departments should perform their

public duties in collaboration with pursers, scribes, coin-experts, treasurers, and the armed personnel.

Those, who are attached to military officers and have good record of service, should be deputed for espionage on the work of the civilian officers.

Every department should be manned by several tenure heads. This should be observed as a safeguard against fraud by a state official. It is difficult to discover misappropriation among state officials as it is to find out when the fish drinks water.

Fraudulent administrators should not only be deprived of their ill-earned wealth, but also transferred from one office to another to prevent further misappropriation of state funds.

Administrators who enhance state revenues should be ensured of their tenure of service.

Chapter 30

DIRECTOR OF STORES

THE director of stores should control the accounts of farm products; farm levies, trade, barter, gifts of grains, grain loans, processing of grains and oils, other source of incomes, balance of expenditure and farm liabilities.

Whatever produce is transferred from state farms by the manager of state lands should be entered under a separate head.

Farm levies include: fixed levies; taxes that are paid as shares of produce, military provisions supplied for marching forces by the people; tributes and contributions for religious purposes; baronial contributions and subsidies; presents and gifts on royal occasions; marginal levies; compensatory contributions for damages; royal dues; special taxes on lands irrigated by state reservoirs.

Trade sources include: sale of grains; purchase of grains and grain premia.

Barter is exchange of grains for grains.

Grain gifts include grains collected by begging.

Grain loans are transactions in grain covered by promise of repayment.

Processing of grains and oils means husking of rice, cleaning of pulses, parching of corns, fermenting of beverages, grinding of grains, milling of oils and extracting of sugar from sugar-cane.

Other sources of incomes include miscellaneous sources creating windfalls like lost and neglected items.

Balance of expenditure covers that which is extricated from a wrecked enterprise and what is saved from expenditure on estimated outlay.

Oils cover clarified butter, edible oils, fats, and kernel extract of plants.

Of the stores thus conserved, half should be used to build up store reserves and only the other half released for consumption. Old stores should be replaced by new supplies. The director should also control the increase or decrease effected in husking of grains, cleaning and parching or in drying as the case may be.

Chapter 31
DIRECTOR OF TRADE

THE director of trade should estimate the demand or absence of demand for and fluctuations in price of various kinds of goods which may be the products of land and water and which may have been conveyed either by land or water. He should also survey the time suitable for their distribution, conservation, purchase and sale.

Merchandise whose sources of supply are widely distributed should be centralised and the price enhanced. When the price becomes effective, another price should be promulgated.

State stores of local manufacture should be centralised. Imported goods should be distributed over wide markets for sale. All goods should be sold to the people at favourable prices.

The director should not charge such prices as will harm the people.

There should be no barrier to the time for sale of those articles for which the demand is recurring nor should they be exposed to stock-piling.

Or dealers may sell state goods at fixed price at different markets covering their losses by subsidy. The amount of discount on articles sold by cubical measure is 6¼ per cent of goods, that on goods sold by weight is 5 per cent of the quantity; that on goods sold by quantity is 9 per cent.

The director should allow facilities for importers of foreign goods. Shippers and traders dealing in foreign goods should be given tax-redemptions to aid them in making profits.

Foreigners, except corporations and partnerships of local origin, should have] exemptions from debt suits. State goods must be sold under regulations governing daily sale of such goods and accounting.

With regard to state-trading in foreign countries, the director should get estimate of the value of the local commodities which can be bartered for foreign articles, and estimate the margin of profit left to cover charges payable in the foreign land like duties, road cesses and transport charges, military levies, ferry charges, working expenses for the merchant and his retinue and the share to be given to foreign government. If no profirt can be realised, the director should ascertain if any local produce can be exchanged for any foreign produce. He may so arrange as to send one quarter of the valuable merchandise by safe routes to different land-markets. He may make valuable trade and diplomatic contacts with guards, city and rural officers. He should save his wealth and life in danger. If he faces any barrier to this destination, he may sell his merchandise in any market *en route*. Or he may divert his merchandise to other markets through waterways.

The merchant should obtain information *en route*, as to market conditions in trading centres and divert his merchandise to profitable markets avoiding unprofitable ones.

Chapter 32

DIRECTOR OF TARIFFS

THE director of tariffs should erect near the main city gate a tariff station and its flag for identification. When traders arrive

at the tariff station with their goods, four or five tariff collectors should note down the names of traders, their residence, the quantity of goods carried and the origin of the identification seal placed on the goods.

Unstamped goods should pay twice the amount of standard tariff ; counterfeited seals carry a penalty of eight time the tariff. Substitution of seal, or substitution of goods, classification for purposes of tariff calculation would expose the traders to penalty tariffs for each standard measure of goods.

There should be near the tariff station facilities for the traders to sell their goods for the bidders agreeing to pay the price demanded.

When there is competitive bidding for goods, the highest bidding price together with the tariff on the goods should be paid into the exchequer. When attempt is made to evade the tariff by lowering of the price of goods auctioned, the traders would be liable for penalty tariffs eight times that of standard tariff. The same penalty will also cover cases where the real value of goods is camouflaged with lower value samples or where high value goods are smuggled under a layer of inferior goods.

When fraudulent inflation of prices of goods is made to evade competitive bidding for the goods offered, twice the amount of tariff should be imposed on the traders as penalty and collected for the exchequer. A similar punishment or eight times the tariff should be imposed on the director of tariff if he is a party to concealment of the real value of goods.

All goods should be sold only after they are accurately measured, weighed or counted.

Where inferior goods or tariff free goods are concerned, the amount of tariff remitted should be carefully determined and recorded.

Those traders who smuggle beyond the flag of the tariff station should be penalised with eight times the tariff evaded.

The following goods are tariff-free: goods intended to be used in marriages, taken as bridal presents by bride, intended as presents, for sacrificial purposes, for *accouchement* of women, for religious purposes, for social ceremonies, ceremonial gifts.

Those who perjure to evade tariffs should be punished in the

same manner as those have committed theft.

Traders who smuggle a part of goods on which tariff has been paid by mixing it with passed goods, as well as those who use the tariff pass to smuggle goods a second time, will forfeit the smuggled portion and pay a penalty equal to the tariff on the quantity smuggled.

Any one attempting to smuggle goods under false solemn declaration will be sentenced to the highest penalty.

Any one attempting to import forbidden goods like weapons, armour, metals, vehicles, precious stones, grains and cattle, would forfeit the goods. Any such goods brought for sale would be sold free of tariff to the Exchequer outside the tariff station.

Goods which are harmful to the country should be prohibited and whatever is of great value to the country as well as seeds not available easily in the country, should be allowed free of tariff.

Chapter 33

TARIFF REGULATIONS

ALL commodities—those which are products of rural parts, manufactured in cities or imported from foreign countries—are liable to payment of tariff both when they leave and when they arrive at the tariff station.

Imported goods should bear twenty per cent of their value as tariff.

The following goods should bear sixteen and two thirds per cent as tariff: flowers, fruits, vegetables, tubers, bulbous products, seeds, dried fruit and cured meat.

Tariff on the following articles should be determined by experts on cost calculations : hard marine products, diamonds, precious stones, pearls, corals and jewellery.

The following goods bear a tariff of 7 to 10 per cent: textile goods, cotton and silk products, armour, chemical products, metals, colours, wines and liquor, ivory, skins, yarn carpets and coverings, insect products, wool and other farm-animal products.

The following goods bear a tariff of 4 to 5 per cent: cloth, quadrupeds and bipeds, threads, cotton, perfumes, medicines, wood, bamboo, fibres, skins, clay pots, grains, oils, glucose, salt, wine, processed rice and products.

Gate-toll should be 20 per cent of tariff dues, and may be remitted at the discretion of the officer. Goods should not be sold where they are grown or produced. When minerals and other goods are bought at the mines heavy penalty would be imposed. Similarly when flowers or fruits are bought from flower gardens or orchards. So also is the case with vegetable and other farm products.

The tariff should vary with the customs of the countries or of the commodities, old or new, and fines governed by the seriousness of the offences.

Chapter 34
THE DIRECTOR OF TEXTILES

THE directorate of textiles should supervise the manufacture of yarn, piece goods, textiles and ropes.

Those employed to shear wool, prepare fibre, gin cotton and make hemp and flax are widows, physically incapacitated women, dedicated women, women constrained to offer service in lieu of penalties, mothers of courtesans, old women-servants of the ruler's household, courtesans who have abandoned their traditional social services.

They should be paid wages in accordance with the quality of produce manufactured and the quantity of goods made. The wages may be paid in kind consisting of oil and cake rations. On holidays they may be paid special wages. Wages may be reduced according to shortfalls in quality and quantity.

The director should closely associate with the workers.

Special bonuses and rewards should be given to workers manufacturing textile goods, dresses, silk and woollen cloth in the form of perfumes, flowergarlands, or any other coveted goods.

Those specially trained should manufacture mail armour.

Women, not accustomed to work in factories but who are

compelled to work for livelihood, women whose husbands have migrated abroad, handicapped women and girls, should be supplied with work at their own places through the women-servants of the department.

Those women who can come to the factory early in the morning may collect their wages in exchange for the yarn they have spun. Only such light as is essential for yarn testing should be kept. If the director casts looks at the women workers or indulges in off-professional talks, he should be suitably punished. Payment delays also are liable to punishment, so also payment of wages for work not done. Those who receive wages for work not done shall be penalised. So also those who misappropriate or steal or abscond with the materials supplied to them by the factory. The director should associate with his workers intimately.

Chapter 35

THE DIRECTOR OF FARMING

WITH expert knowledge of the science of farming concerning shrubs and trees or with the assistance of those possessing expert knowledge of these sciences, the director of farming should conserve, in time, seeds of all varieties of grains, flowers, fruits, vegetables, bulbous roots, roots edible, greens, fibres and cotton.

He should cultivate state lands with the help of slaves, labourers and prisoners. They should be supplied with farming implements and farm cattle. They should be assisted by ironsmiths, carpenters, rope makers and persons who capture pests. All losses from the aforesaid persons should carry fines equal to the loss.

Uncultivated lands should be cultivated by share croppers, or by farm labourers for a quarter of the produce or by those who pay a reasonable tithe to the state.

Where irrigation is done by manual labour, 20 per cent of the produce will constitute water-rate; where water is borne on shoulders, 25 per cent; where irrigation is by lift 33 per cent; where irrigation is by rivers or lakes from 33 per cent to 25 per cent of produce should be water rates.

The director should grow wet, winter and dry crops on suitable lands where labour and irrigation are available.

Chapter 36
CONTROLLER OF WINES

WITH the assistance of experts in the brewing and making of liquors, the controller of wines should carry on wine trade not only in cities and rural parts, but also in camps.

The sale of wines and spirits may be regulated by the controller according to market conditions, either by centralisation or by decentralisation of distribution.

Drinks should not be taken out of villages. Bars should not be in close proximity to each other.

Drinks should be sold only in small quantities to persons of established standing to prevent alcoholic disorders among labourers, respectable citizens and delinquents. Only respectable citizens should be allowed to carry drinks outside the bar.

Customers should be constrained to consume their drinks within the bar and close observation should be kept over them to discover their antecedents and activities, while under the influence of drink specially for theft. If any possess gold and other costly goods without adequate title to them, the controller may effect their arrest outside the bar. Likewise those who indulge in extravagant drink and expenditure.

Standard drink should not be sold below the settled price. Substandard liquor should be sold outside or given to slaves in lieu of wages or to animals.

Bars should contain beds and seats apart from drink parlours. The drink parlour should contain seasonal flowers, scents and other amenities.

Espionage should be organised in bars to discover whether the customers are spending extravagantly to their means and to watch the movements of strangers. They should also watch the dress, valuables and money of the customers under influence of drink. When customers, under drink, lose their valuables, the bar owners should not only make them up, but also pay an equal

penalty to the state.

Bar personnel should observe, concealed, the demeanour of any local or foreign customers who indulge in drinking bouts with their attractive mistresses.

On special occasions, householders may be allowed to brew permitted wines, or medicinal alcoholic decoctions.

During festivals, social gatherings and pilgrimages, right of private brewing may be allowed for four days.

Those who trade in wines other than those of the state, should pay a licence fee of five per cent.

The Controller should fix the state dues on wine trade on the basis of the magnitude of sale and the different measures employed at the bars.

Chapter 37

CONTROLLER OF COURTESANS

THE controller of courtesans should employ under state patronage, on a substantial salary, a courtesan, whether born or not in a courtesan family, and celebrated for her beauty, youth and grace.

An understudy on half the above salary should also be employed.

When the courtesan goes abroad or dies, her daughter or sister should officiate for her and receive her emoluments. Or her mother may select another courtesan. In the absence of any such arrangement, the emoluments revert to the state. Courtesans should be classified according to their beauty and talents.

A courtesan whose beauty has faded or is lost should be appointed as a nurse.

A courtesan can compound her public services for a sum of money and her son for half the prescribed amount.

From the age of eight, a courtesan should hold musical entertainment.

Courtesans, old women and women slaves who cannot professionally entertain may be employed in other services.

A courtesan, who becomes the mistress of a private citizen,

must pay a fee to the state.

The controller should estimate the earnings, the property, income and expenses of every courtesan. He should control their extravagant expenses.

No person, other than the mother, should receive the moveable property of a courtesan. If any one does, he shall be liable to penalty. No courtesan can sell or mortgage her property. Such a transaction will carry penalty.

If a courtesan defames, she must pay penalty. Double penalty for causing hurt and more for disfiguring any one.

No man can have intercourse with a courtesan against her consent or with a nymphet. Such crimes carry capital punishment.

When a courtesan does not obey the ruler's order to entertain anyone, she will be whipped or be made to pay a prohibitive penalty. If a courtesan does not entertain a client after receiving fees, she should pay penalty of double the amount of fees received. If a courtesan murders a client, she will be burnt alive or drowned.

When a client steals a courtesan's jewellery, he will be fined eight times the value of the goods stolen. Every courtesan must supply to the controller information about the daily earnings, her estimated income and the name of her client. Every courtesan should pay to the state two days' earnings every month.

The state should maintain those who teach courtesans, female slaves and actresses the arts of singing, instrumental music, reading, dancing, acting, writing, painting, mind reading, perfumery and garland making, massaging, and arts of entertainment.

The teachers should train sons of courtesans as stage actors.

Wives of actors and persons of that category, trained in various languages and symbols, should be appointed to seduce and liquidate foreign spies.

Chapter 38

CONTROLLER OF SHIPS

THE controller of ships should supervise shipping accounts relating to oceanic, riverine and lake shipping in the neighbour-

hood of towns and cities.

A fixed tax should be paid by villages on seashores and on the banks of rivers and lakes.

Fishermen should pay one-sixth of their haul as licence fees.

Merchants should pay tariffs imposed in port towns.

Passengers on board the ships should pay passenger levies.

Those who use state boats for fishing for pearls and marine products should pay the fixed amount of hire or use their own private boats.

The controller should strictly honour the traditions of trading towns and the orders of city officers.

A storm-struck ship should be treated with tenderness. Ships in distress shown consideration with regard to tariffs. Ships of pirates and vessels which violate the port rules should be destroyed.

The following persons can cross rivers at any time: fishermen, fire-wood carriers, transporters of grass, flowers and fruits, gardeners, vegetable dealers, persons chasing criminals, army provision carriers, those who supply food and necessaries to flooded areas, guests, children, the old and the infirm, royal messengers, and pregnant women.

Alien traders who often visit the country and those known to local merchants should be allowed to disembark at port towns.

The following persons should be arrested: abductor of another's wife or daughter, smuggler of another's wealth, a suspicious person, agitated person, one with no luggage, a person who does not declare the true value of his luggage, a person who attempts to journey in disguise, one who simulates illness, one who appears alarmed, one on a secret mission or carrying fire arms, one who carries poison and one who has travelled without pass.

The controller should arrange for the collection of toll, freight charges and road levies and for confiscation of the property of the person travelling without authority. He should also regulate the load of ships, the times of departure or the condition of water-craft and cover the losses as a result of fault in any of these directions.

Chapter 39
CATTLE CONTROLLER

THE cattle controller should supervise cattle managed for hire; cattle given for a fixed daily product; cattle which are useless and deserted; cattle maintained for a share of dairy products; classified cattle; stray cattle; lost cattle and accumulated share of milk and butter.

(a) When cattle are managed for wages by cowherds, dairy workers and hunters, the system is known as managing cattle for hire.

(b) When a single cowherd manages a group of cattle consisting of aged cows, milk cattle, heifers, and calves and gives to the owners an agreed quantity of dairy produce, it comes under the second category.

(c) When persons manage a cattle herd accustomed to definite persons and fierce and unruly cattle, for a share of dairy produce, the category is called "useless and abandoned cattle."

(d) When cattle are handed over for safety to the controller, paying him one-tenth of the dairy produce, they come under the fourth category.

(e) Classified cattle constitute cattle classified by the controller as calves, steers, tameable cattle, draught oxen, yoke bulls, breeding bulls, meat cattle, buffaloes for dairying and for draught, barren cattle, and are branded separately and the brands are registered with colour and other descriptions.

(f) Stray and lost cattle are those that have been stolen or have strayed.

(g) "Irrecoverably lost" are cattle lost on mires, which die of disease or of old age or drowned or killed in accident, or by lightning or carried away by tigers and crocodiles or destroyed in forest fires.

Cowherds should guard their cattle from such dangers.

Any injury to a cow, or theft of it, is punishable with capital punishment.

Substitution of state cattle by private cattle carries a penalty. Diseased cows should be treated, and retrieved cows, rewarded. The cattle should be grazed in pasture ground protected from

human and animal marauders by hunters and hounds. Cattle
should be belled for identification and protection. Lost and
diseased cattle should be reported. Dead cattle should be
accounted for by the cowherds by skins and other parts or the
body of cattle so lost. All cattle should be supplied with
abundance of fodder and water.

A herd of 100 asses and mules should have 5 male animals,
herd of goats and sheep ten, and a herd of ten cows or buffaloes
should contain four male animals.

Chapter 40
CITY ADMINISTRATION

THE city administrator should look to the affairs of the city.

An inspector should keep the accounts of ten households,
twenty households or forty households. He should not only know
the ancestry, name and vocation of both men and women in
each household, but also information about their income and
expenditure.

Another inspector should attend to the affairs of the four
quarters of the city.

Managers of travellers' rest houses should send information
to the inspectors about any travellers seeking shelter with them.
They should allow travellers to reside in their institution only
when their antecedents have been ascertained.

Craftsmen and artisan can, on their own responsibility, permit
persons of their own professions to reside with them. So too
traders.

The traders should send in detailed reports about those who
transact business in solicited areas or times as well as those who
carry goods not their own.

Wine dealers, dealers in food and courtesans can allow persons
to stay with them only when they are well-acquainted with
them.

Any doctor who treats clandestinely a patient suffering from
wounds or excess of bad food and drink as well as the house-
holder who provides hospitality to such person should report the

cases. Otherwise, they become punishable.

All strangers arriving or departing from their houses should be reported by householders. Travellers should apprehend persons suffering from wounds or ulcers, possessing lethal weapons, fatigued with heavy loads, moving suspiciously, sleeping or fatigued by long travel, or strangers inside or outside the city.

Fire control measures should be enforced and fines imposed. All cooking must be carried out in the open. Each householder should keep fire fighting equipment like water pots, a big water holder, a large water-tub, a ladder, an axe, a winnower to blow off fire, a long hook, pincers and a leather bag under pain of penalty: thatched roofs should be removed and blacksmiths segregated. Each householder should be present at night in his house.

Water vessels should be kept in row in thousands in all streets and at road-junctions. And in front of every big house including the ruler's residence. All citizens should render service in times of fire: those who do not, should pay penalty for default.

Throwing dirt in the street is punishable with penalty; flooding the street or collecting muck are also punishable. The penalty is double when the nuisance is committed in public and state roads.

Whoever commits nuisance in shrines, water-tanks, temples and state buildings shall be punished with penalty. Where such offences are due to medication or disease, they are exonerated. Throwing of carcases in the city is also prohibited. All deceased should be consigned or cremated in allotted grounds.

There should be a curfew between 9 P.M. in the night and 4 A.M. in the morning, proclaimed by a trumpet, when people are forbidden to move out. Fines are imposed on violation of the curfew.

The curfew does not affect those who go out on medical service, who go out to bear corpses for disposal, who move about with a lamp in hand, who are on a visit to the city authorities, who investigate trumpet calls, who go to fight fires and who go under a pass.

There should be nights when curfew is lifted. Those guards who obstruct those whom they should not obstruct and not

obstruct those whom they should obstruct will be heavily punish-
ed.

When a guard carnally assaults a slave women, he should be
awarded mild punishment; if she is a free women, he should
receive heavy punishment; if the woman is a woman arrested for
jumping curfew, the highest punishment; if the woman is a
respectable lady, the guard should be destroyed.

When the city administrator does not send a report of nightly
happenings in the city, articulate or inarticulate, and shows
negligence of duty, he should be punished suitably.

The administrator should inspect daily reservoirs of water,
the open and secret passages to the city, and the defensive works
of the city.

On the days when the ruler's birth star occurs and on full
moondays, prisoners who are young, old, diseased and orphaned,
should be released as well as those whose sentence is purchased
by charitable persons.

Once in a day, or once in five nights, all city jails should be
emptied of prisoners with their sentences remitted for work done
or corporal punishment received or for ransom paid in gold.

All prisoners should be set free when an heir apparent succeeds
to the throne, or a son is born to the king or a new country is
conquered.

Book III

INTER-STATE POLICY AND ADMINISTRATION

Chapter 41
DECAY, STABILISATION AND PROGRESS
OF STATES

Every state can be said to have a sixfold policy as against any other state.

Ancient thinkers hold that armistice, war, neutrality, invasion, alliance and peace are the six principal policy-relations. Sixfold policy can be reduced into peace, which means concord supported by pacts; war, implying armed aggression; neutrality involving nonchalance; armed invasion against another power; alliance involving appeal for assistance to another power; biformal policy involving making war with one and suing for peace with another.

Any power inferior to another should sue for peace; any power superior in might to another should launch into war; any power which fears no external attack and which has no strength to wage war should remain neutral; any power with high war-potential should indulge in invasion; any debilitated power should seek new alliances; any power which tries to play for time in mounting offensive should indulge in biformal policy of making war with one and suing for peace with another.

A state should always observe such policy as will help it strengthen its defensive fortifications and life-lines of communications, build plantations, construct villages, exploit mineral and forest wealth of the country, while at the same time preventing fulfilment of similar programmes in the rival state.

Whoever estimates that the rate of growth of the state's potential is higher than that of the enemy can afford to ignore such an enemy.

Any two states hostile to each other, finding that neither has an advantage over the other in fulfilment of their respective programmes, should make peace with each other.

No state should pursue a policy which, while not enabling it to have means to fulfil its own programmes, does not impose a similar handicap on its neighbour: this is the path to reversion.

When any state evaluates that its loss over time would be much less than its acquisition as compared with its rivals, it can afford to ignore its present recession.

When any two states which are rivals expect to acquire equal possessions over the same span of time, they should keep peace with each other.

Stagnation occurs when there is neither progression nor regression. When a temporary stagnation is expected to lead to greater rate of growth than that of the rival, the stagnation can be ignored.

A state can augment its resources by observing peaceful pacts with an enemy in the following situations :

Where, maintaining peace, productive operations of strategic importance can be planned and executed, preventing the rival state at the same time in fulfilling similar programmes;

When under the terms of the peace pact, the state can enjoy the resources created by the productive projects of its enemy in addition to its own resources;

When the state can plan works of sabotage through espionage on the plans and projects of its enemy;

Where under powerful incentives of happy settlements, immigration concessions, taxexemptions, pleasant work-conditions, large profits and high wages, immigration can be induced, of strategic workers from an enemy state;

Where because of a prior pact, the enemy can harass another state which is also hostile;

Where because of invasion of the enemy state by another power, the workers of the enemy state immigrate and settle down in the state;

Where because of damage to the productive sectors of the enemy, his potential for offensive is reduced;

Where the state can, by pacts with other states, increase its own resources;

Where a sphere of alliance is formed of which an enemy state is a member, the alliance can be broken by forming fresh alliances.

A state can increase its own resources by preserving hostility with another state in the following situations:

Where the state is composed of military races and war-like corporations;

Where the state has natural defensive fortifications like mountains, woods, rivers and forts and capable of liquidating the enemy's offensive;

Where harassing operations can be launched on an attacking enemy from powerful fortifications in the states;

Where internal disorders sabotage the war potential of the enemy;

Where invasion of the enemy by another hostile power can be expected to create strategic immigration of skilled workers into the state.

A policy of neutrality can be sustained in the following situations:

Where the balance of power between states is even: as when neither state can immobilise the other;

Where, in the event of an attack, the state can intensify the tribulations of the enemy without loss of its own strategic power.

A state can indulge in armed invasion only:

Where, by invasion, it can reduce the power of an enemy without in any way reducing its own potential, by making suitable arrangements for protection of its own strategic works.

A state should form alliance with a powerful power where its potential is strong neither to harass its enemy nor to withstand its offensive. It should also attempt reconstruction of its potential from the stage of regression to that of stabilisation and from that of stabilisation to that of progress.

A state can pursue a biformal policy where it can benefit in resources by maintaining peace with one enemy, and waging war with another.

The central aim of inter-state sixfold policy is to enable a state to advance from a conditon of regression to progress through the intermediary state of stabilisation or balance of the forces of advance.

Chapter 42

ESSENCE OF COLLABORATION

WHERE the benefits derived from war and peace are balanced, one should opt for peace: for war has certain additional dis-

advantages like decrease of authority and resources, demobilisation and disaster.

The same attitude holds good for neutrality and war.

Of the two policies, the biformal policy of making war with one and peace with another, one should always prefer the former: because by pursuing biformal policy one enriches oneself through eternal vigilance, whereas by having collaboration with another, the state will have to help its ally at its own expense in times of attack.

One should sue for collaboration with a power stronger than one's rival. Where such a power is not available, it is wisdom to propitiate the enemy either through tributes or through supplies of army or through cession of part of one's territory. Collaboration with a state of considerable might, unless in times of grave danger, may turn into the greatest disaster for a state.

An incapacitated power should conduct itself like a vanquished state before an enemy; but when it finds that its own rise into power is imminent due to civil commotion, disaster, increase of interstate tensions or a third ally's catastrophe, it should devise measures to further debilitate its enemy.

A state located between two powerful states should seek collaboration and protection from the stronger of the two. It may also sue for peace with both on equal terms. Or create diplomatic tension between the two. In the event of a conflict, the state should attempt to destroy the more vulnerable of the two.

The state so situated may also seek aid from other powerful states or pursue a biformal policy. Or alternate its policy between peace and war with changing diplomatic situations. Or pretending collaboration with one of the states, may exploit the weakness of the enemy through espionage. Or extending collaboration among other states form a powerful sphere of alliance. Or collaborate with a powerful neutral state and engineer involvement of that state in war. Or forge alliances with other states whose subjects are well disposed or have traditional relations with it, and among whom the state can have powerful friends.

Of the powerful states which are on friendly terms, a state should form collaboration with one which is nearest to it in identities of interests and perspectives.

Chapter 43

NATURE OF COORDINATE, MINOR AND MAJOR POWERS: PACTS MADE BY MINOR POWERS

A STATE launching into aggrandisement should employ the aforesaid sixfold policy.

Pacts should be made with coordinate and major powers: a minor state should be invaded. Invasion of coordinate powers would spell disaster.

If a major power rejects rapprochement from a minor power, the latter should conduct itself like a vanquished power.

If a state of coordinate status rejects the proposal for a pact, the dissenting state should be harassed through diplomacy. It is puissance that can ensure peace between states.

When a minor state is all prostrate, pact must be made with it: when harassed, minor state will become an aggressor and may also be supported by its allied states.

When a state, in times of peace, finds that its rival state is not taking steps to alleviate the misery and distress of its subjects by permitting them to emigrate, it should proclaim war on the offending state, though itself be a minor power.

In times of war, when a state finds that its enemy state is not allowing its subjects to come over to the other state because of war, then it should make pact with the enemy though itself be a major power.

When one of the states, in a situation of war with another, discovers its own troubles to be far greater than those of its enemy and not powerful enough to conquer the troubles, the state should negotiate for peace.

When a state, though a major power, finds neither loss to its rival nor gain to itself should uphold neutrality.

When a state, though a minor power, finds the tribulations of its enemy insurmountable, it should invade it. When a state is assailed by danger, it should negotiate for alliance with another though itself be a major power.

When a state is certain of reaching its desired goal by waging

war with one and negotiating peace with another, it should pursue the biformal policy.

The above is the essence of inter-state diplomacy according to the sixfold policy of statecraft.

These forms of policy are applied as under :

When a minor power is invaded by a major power at the head of a group of allied states, it should surrender itself by offering ransom, relinquishing the army or ceding territory.

Agreements can be made demanding the surrendering of the head of the state with the cream of the army or the surrender of a fixed number of troops.

Agreement can be made demanding specific personal hostages; like the commander of the army or the person next to the head of the state.

Agreement can be made demanding the presence of the head of the state or some other person at the head of the army at a specified place :

Attempts can be made to capture the enemy in any of the above agreements.

When the sovereignty of the state can be purchased by offer of money, it becomes purchase of peace at a price. When the states making peace pact are harmoniously reconciled to each other, the peace becomes "golden peace."

When very heavy war indemnity is demanded and paid, the peace is called "skull peace."

In the first two kinds of pact, resources should be sent with a view to getting them back. In the third, indemnity should be paid in cash. In the fourth, payment of indemnity should be evaded on grounds of loss or disaster.

When the entire territory of a state, with the exchequer of the capital is ceded, the pact is called "armistice of distress." And is of advantage where the ceded territory can become an arsenal of reaction against the occupying state.

When a tribute is paid to maintain peace which is part of the exchequer, the peace becomes "rented." When the tributes are in excess of the revenue, it becomes "laced peace."

The state making the first form of peace, should abide its opportunity to throw it out. In the case of the latter two, peace ne-

gotiation should not be made except under force of submission
due to the circumstances, times and one's own situation.

Chapter 44

DIPLOMATIC MANOEUVRES

NEUTRALITY comprises of seclusion, retirement from hostility
and diplomatic manoeuvres. Seclusion is maintenance of a policy
of privacy; retirement from hostility is suspension of aggressive
acts in one's own interest; diplomatic isolation is seclusion from
all measures and strategic steps against the enemy.

When two states, intent on invasion, are desirous of peace and
are unable to proceed against each other, they may remain
neutral after proclaiming war, or after signing peace.

When a state is confident of subduing another state of coordi-
nate status or of superior might, with the help of allies, it may
maintain neutrality after proclaiming war and attempt building
up its own defences.

When a state is confident of the gallantry, solidarity and affl-
uence of its own subjects, and of their ability to mount an offen-
sive against the enemy without impairing their war potential,
it may remain neutral after proclaiming war.

A state may remain neutral after proclaiming war in the under-
mentioned situations:

When a state discovers that its enemy's subjects can be intrigued
to desert the enemy being ill treated, impoverished and greedy,
and incessantly being harassed by armed marches;

When a state finds its own farming and trade flourishing, while
those of its enemy are in recession;

When a state is convinced that secular distress in the enemy's
territory is creating exodus of population;

When a state is satisfied that, though caught in secular reces-
sion, its subjects will not emmigrate;

When a state is assured that it can acquire the enemy's re-
sources by armed invasion of its territories;

When a state is certain of preventing the import of enemy's

goods which are destructive to its own trade;

When a state anticipates the flow of refugee resources from the enemy's territory;

When a state is assured that declaration of hostility would lead to civil war in the enemy's territory;

When a state perceives that its allies would support it in an armed march against the enemy to share the booty of invasion.

Whichever state has the necessary strength can remain neutral after proclaiming war.

When the policy of neutrality after proclaiming war is suspected of creating adverse results, a state should remain neutral after making a pact of peace.

When a state has grown in its power by remaining neutral after proclaiming war, it should march on its enemy.

A state should invade an enemy after declaration of war under the circumstances noted below:

When its enemy is involved in disturbances;

When the misfortunes of the enemy's subjects cannot be overcome;

When the enemy's subjects are oppressed, ill-managed, their loyalty disintegrated, their secular possessions impoverished and they have lost their courage;

When the enemy's territories are swept by calamities like fire, floods, diseases, famines and death and the cream of its youth is being destroyed and its defences debilitated;

When powerful allies are surrounding the enemy;

When an ally has strength to check the enemy either in front or in the rear.

When a state anticipates a quick victory, single-handed, then it may invade an enemy in front after declaring war on the enemies in the rear; otherwise it should attempt invasion of an enemy only after entering a pact with the enemies in the rear.

When a state discovers that the enemy cannot be handled single-handed it should form an alliance with coordinate, minor and major states, sharing the booty on proportionate basis when the objective is determinate and keeping a flexible policy with regard to spoils of victory where it is indeterminate. Where such an alliance cannot be achieved, the state may appeal to another

state for supplies of arms or army under determined terms, or to join the invasion for an equal share of the spoils.

Chaper 45

INVASION

WHERE two enemy states, one an assailable enemy, the other a powerful one are both involved in disorder, which of them is to be invaded first?

The powerful one should be subdued first; after its conquest, the other state should be invaded. When a strong enemy has been conquered, the weaker one would volunteer to help the conqueror; not so the powerful one.

Which is to be invaded first : a weaker state involved in greater troubles or a stronger state involved in lesser troubles?

The stronger state should first be invaded : because the disorders of the stronger state would get multiplied under invasion. Though the greater troubles of the weaker state would also get multiplied under invasion, if the stronger state is left to itself, it may form an alliance with the enemy states and get rid of its internal disorder by shifting attention to conquest.

Where two weak states—one well governed but assailed by difficulties and the other ill governed, but with less difficulties and with disintegrated loyalty of the subjects—which is to be invaded first?

The state should invade the enemy with disloyal subjects first, since a well governed state, though assailed with greater difficulties, would be helped by subjects whose loyalties are not disturbed.

Who is to be invaded first: an enemy state whose subjects are impoverished and ambitious or a state whose subjects are oppressed?

Since an impoverished state with ambitious subjects may sustain a higher degree of loyalty to the state, the state should invade an enemy state when subjects are oppressed and loyalties strained.

Who is to be invaded first: a powerful state which is corrupt

or a weak state which is righteous ?

The powerful state with corrupt administration should be attacked first, because of the low level of popular loyalty and the possibility of factions moving over to the invader's side. The other state, when attacked, may be powerfully defended by the loyalty of the subjects.

No state should govern its subjects in such a manner as to create impoverishment, greed or disloyalty among them; if these appear, steps should be taken to remedy the situation.

Disorders can be caused by the following factors:

By insulting the gracious and rewarding the crafty and causing needless destruction of life;

By ignoring the observance of socially approved customs and encouraging dubious mores;

By acts of omission and commission which create fresh friction and by default of rewards and by obnoxious levies;

By granting pardon to the punishable and punishing severely the less guilty; by arresting or restraining those who ought not to be arrested or restrained;

By undertaking risky enterprises and neglecting reward-yielding state enterprises;

By neglecting law and order at appropriate junctures and by heavy extortions;

By abandonment of noble works and condemnation of honest enterprise;

By insulting popular leaders and disregarding the worthy;

By annoying the aged, by fraudulent dealings and by corrupt transactions;

By all these acts and foibles, the scourge of impoverishment spreads among the people. Impoverishment leads to disloyalty and disloyalty to debilitation of the state. This will lead to its dismemberment and final dissolution.

No state should, therefore, create a situation which leads to impoverishment among its subjects. Remedial steps shoud be taken to combat it.

Which is the worst—an exhausted people, an avaricious people or a disloyal people ?

An exhausted people lives in constant fear of oppression and

of ruin by taxation and overanxious to alleviate their plight by evasion, or by uprising or by emigration.

An avaricious people is constantly annoyed and becomes an easy prey to foreign machinations.

A disloyal people awaits any opportunity to rebel against authority.

When emigration and attrition threaten a people because of growing scarcity of gold and grain, the situation can only be relieved with great difficulty. The scarcity of efficient personnel can be retrieved by use of gold and grain. Avarice is always sectional and can be removed or sated by armed expeditions into the enemy territories. Disloyalty can be combatted by suppression of leaders. People first disperse, when their leaders are suppressed and, when they are restrained, they endure the situation.

Having carefully weighed the situation creating war or peace, a state should form alliances with mighty and upright powers and invade an enemy. A mighty power is one which has sufficient striking potential to put down an enemy or give adequate aid for an invasion. An "upright power" is one which keeps its pacts, irrespective of consequences.

Equipped with an alliance with a superior power or with two states of coordinate status, should a state invade an enemy?

It is better to invade with two states of coordinate status than with a superior power. In the latter case, the possibility of the superior power walking out of the expedition is incessantly threatening. Whereas with two coordinate powers, a state has the means of following a firmer alliance with one and punishing the recalcitrant power.

Allied with a state of coordinate status or with two states of lesser status, should a state invade an enemy?

It is wiser to invade with two states of lesser status, as they can be easily managed in case of victory over the enemy.

Till the execution of a special alliance, the manoeuvres of an ally of dubious integrity should be carefully watched either by sudden unsuspected manoeuvres or through heavy ransom.

Even in the case of a more integral alliance, a state of coordinate status may shift its loyalty, specially when there is danger

of disturbance to the prevalent balance of power among the states forming an alliance.

Alliance with a superior power is always fraught with apprehension. Though after conquest of the enemy, the superior power may apparently retire with satisfaction and be pleased with a share of the spoils or separation, it may design to return to restore or improve its own status among the states.

The state operating as the focus of an alliance should attempt to satisfy all its allies after victory over the enemy and follow the line of least resistance in the matter of distribution of the spoils of victory. It is only in this manner that a state can strengthen the sphere of influences it has built up.

Chapter 46
STRATEGY OF PEACE

THE conqueror should always attempt to outmanoeuvre his enemy by deluding him with a coordinate share of the spoils of invasion.

If the spoils are coordinate, it is a pact of peace; if it is otherwise, the enemy is outmanoeuvred

Any agreement of peace may contain a promise of specific performance or can be general. It may relate to a specific work, or be confined to a specific locality or to a specific span of time or to a specified objective.

Where invasion has to be carried through unknown topography, the state should make a pact to confine its operations to known tracts or localities.

Where invasion has to be planned through seasons, the state should make a pact to confine its operations to propitious seasons.

Where invasion is likely to create diplomatic friction among neutrals, the state should attempt to reduce friction by confining to operations to the least irritant position of the invasion in order to reduce expenditure and avoid needless complications.

When, with a view to overcoming an enemy, who is rocked by internal disorders, an agreement or pact is made of general

nature with a view to catch the enemy in his weak points, and conquer him, the pact is called a general peace pact.

The strategy of peace has four aspects: peace with no immediate specific objective; peace with positive and binding terms; violation of pacts made; reparation of violate pacts.

In combat, there are three forms: overt combat, screened combat and stifling combat.

When, with the instrument of appeasement and disarmament, a peace pact is initiated and the prerogatives of coordinate, minor and major states are defined in consonance with their status, the pact is a general peace pact.

When through diplomatic interchanges, the peace pact is honoured and the terms kept inviolate and sustained, and all disagreements eliminated, the pact is known as a pact of security.

When breach of pact is proved through espionage or conspiracy, or betrayal, a pact is broken and a breach of pact occurs.

When reparation of pact is made through an ambassador or ally or any other agency, a broken pact is said to have been restored.

When a state is constrained to make a peace pact with a power which cannot be relied on, it should strengthen its defences which are contiguous to that state.

When broken pact is restored, a renegade or an individual favourably disposed towards the enemy, should be employed consistently so as to be diplomatically useful to the state.

Or he may be employed on borders of the state to guard the frontiers against the enemy or guard the tribesmen or the frontier.

Or he may be employed in trade missions abroad to be exposed to charges of treachery or conspiracy with the enemy.

Or he may be liquidated.

When a combat is in the open daylight and in a specific theatre, it is overt combat.

Threatening attack in one direction and attacking in another; sudden attack when enemy is in trouble or his destruction when captured or when lulled into false security; seduction of the enemy's forces, all form screened combat. An attempt to bring over or win over the key officers of the enemy is stifling combat.

Chapter 47
BIFORMAL STRATEGY

A STATE intent on invasion may invade one contiguous state after forming an alliance with its immediate neighbour.

Peace, under such a situation, may be for purposes of either securing a neighbour's army for money, or monetary aid from the ally to raise an army for invasion.

When coordinate states, minor states and major states form an alliance with an invader on the basis of pacts for proportionate sharing of victory gains, the pact is an equipollent pact; a pact which is converse is disparate pact; when the pact ensures disproportionately high proportion of victory, it is contraband pact.

When a superior power is involved in disorder or weakened by secular distress, an enemy state, though of inferior status, may appeal for armed assistance for a consideration proportionate to the assistance proferred. If the state to whom such terms are proferred is powerful enough, it can retaliate and declare war; if not, the terms can be accepted.

When a minor state, in order to gain resources for its own development, launches an invasion and seeks the assistance of a superior state to guard its base and rear for a consideration, the superior state may accept the proposal, if the minor state's policy is approved; if not, war may be declared on it.

When a major power, secure in its strength, intends to inflict loss of men and resources on its enemy engaged on hazardous invasion, it may form an alliance and accept terms less than proportionate to its share in the campaign against the enemy.

A state may circumvent or aid its coordinate states as under:

When a state professes a pact to another coordinate state, appealing for aid of the latter's army to guard its own territory or to assist an ally, for a first consideration, the terms may be accepted if the state's intentions are honest; otherwise, war may be declared.

When a state of coordinate status, which is aid worthy appeals to another power for armed assistance for a proportionate consideration, the appeal may be entertained if the power appealed

to is not strong enough to declare war.

When a state, beset with disorders and with its resources exposed to the strategy of contiguous states, and with unformed militia, appeals to a coordinate state for armed assistance for a proportionate consideration, the appeal may be honoured, if the appellant state is deemed honourable.

When a state intends to subdue another state with disputed and distintegrating authority, or, of sabotaging a plan which would add to its own secular strength and resources, or of destroying its bases and appeals for armed aid to another state, the latter may honour the appeal, if the expedition helps it to liquidate the defences of its enemy, or reducing the border tribes to subjugation, or weakening the striking power of the enemy's ally, or, of strengthening its own striking power or of winning over the allied state's armies to its own side.

When a state intends to extend its diplomatic suzerainty over another state of superior, or inferior status, and ultimately designs to conquer it, it may form alliance with it and agree to pay more than proportionately for armed assistance in reducing an external enemy. The state receiving such an appeal may either accept it, or reject it, or may strategically remain neutral, or may supply the appellant state with its second rate and ineffective armed forces.

The state seeking for a pact, and the state receiving the proposal for a pact of assistance, or alliance, should carefully examine the intentions behind the pact and adopt the policy which is considered to produce good results.

Chapter 48
STRATEGY OF VULNERABLE STATES

A STATE which is vulnerable to attack may avert the attack from another state, or a group of allies, by counterproposals to the state, or group of allies, or manoeuvring for breaking up the alliance through diplomacy, or by buying them off. Such pact, having been made, the terms must be honoured till diplomacy is em-

ployed to destroy the alliance.

When a state is disposed to inflict loss on the intending invader, or to sabotage an undertaking designed to strengthen it, or to intercept it on the march, or at the base, or exact subsidy or reparation from it, it may launch a manoeuvre, with the least profit to itself at the moment.

When a state intends to help an ally or to conquer an enemy, and contemplates the prospects of acquiring resources in future, or utilising the services of the state obliged to it, it may reject pacts of profits at present from a third quarter.

When a state desires to rescue a neighbour from external treachery, or internal disorder, or from the aggrandisement of a major power, it should receive no consideration for any help it renders.

When a state plans to embarrass an enemy state, or to sever an alliance between a friendly state and an enemy, or apprehends an attack, it may foreclose a pact with an ally, extract reparation, and demand specific performance.

States can be classified as those which can undertake compatible function; praiseworthy project, or productive performance; those which are resolute in their projects, and have loyal and hardworking subjects.

A state which programmes for tolerable projects can be said to perform compatible function; which undertakes a praiseworthy project is a beginner of faultless project; which embarks on profitable projects is a pioneer of productive works; which determinedly completes projects begun is a resolute worker; and which can complete any project, because of resolved and loyal subjects, is one which should be brought into an alliance.

A state can build up several different categories of army to help an ally in any specific objective: army of veterans, mercenary army, armies of corporations (auxiliaries of corporations), allied army, irregular army of wild tribes and of captured enemies.

When a state apprehends exhaustion of its fighting forces by an ally, it may discourage them and offer substitute help to the allied power. Where the state is constrained to employ its army with an allied power, it may send such army as can be

efficient in the time, place and weather of operations, in which the ally is involved.

When reparations accruing to a state, under a pact are equal to all the powers—major, minor and coordinate—the pact is termed an alliance; where it is unequal, the pact is constrained pact.

Chapter 49

ACQUISITION OF ALLIES
OR RESOURCES

Of the three kinds of acquisition : of ally, of gold and of territory, the last is the best. Allies and gold can be acquired with the help of territory. Of two kinds of acquisition, of ally and of gold, each can be acquired with the help of the other.

A pact for the acquisition of an ally is fair peace : when one gets an ally and the other gold or land, it is unequal peace and when one gets more than the other, it is pseudo peace.

In the case of fair peace, whoever obtains an ally, or assists an old ally in troubles, has succeeded in strengthening an alliance.

Who is a better ally : an old ally, but unsubmissive, or a new temporary ally of compliant disposition, both acquired through offers of assistance?

A new temporary ally of compliant policy is better; it will be a true friend as long as the assistance lasts: assistance is the base of true friendship.

Who is the better of compliant allies: a temporary ally of considerable prospects or a long-standing ally of limited prospects ?

A long standing ally of limited prospects is to be preferred. A temporary ally of considerable prospects may expect reciprocity of assistance; and may break the alliance, in case of unfulfilled expectations. A long standing ally is a tested ally and, so, firm in its friendship.

Who is better: a powerful ally hard to rouse or a minor ally easily roused?

The latter is the better, since the minor power can be expected

to help in times of emergency and be influenced to one's diplomatic advantage. Not so the powerful ally.

Which is better: a scattered army or an unsubmissive standing army?

The latter is better, since submission can be bought by conciliation and other strategic devices; but collection of scattered troops cannot be effective in emergencies, due to their professional diffusion.

Who is better: an ally of vast population, or an ally of immense gold?

The latter is better since armies and other objectives can be obtained for gold, and an army is not always required.

Who is better: an ally with gold resources, or an ally with vast territory?

The latter is better, since both fresh allies and gold can be acquired with territory.

An ally and an enemy with equal population may yet differ in the qualities of their population, such as bravery, power of endurance, sociability and fighting potential.

Allies of equal resources also may differ in their readiness to help, the magnitude and attitudes of assistance and their accessibility to appeals.

About allies, the following qualities are valuable: constancy, amicability, sympathy, time-worn allegiance, puissance, loyalty—these are the six attributes of good alliances.

An ally with undiluted constancy, and respectful of traditional amity, is a long-standing and constant ally.

An ally who is amiable can be of three categories: one who is amiable to only one; one who is amiable to two; and one who is amiable to all.

An ally who, while professing assistance or receiving aid, stretches a powerful hand over the receiver, or the giver, and has a considerable array of fortifications and armies is a puissant ally.

An ally who, driven to a defensive position, or, under threat of disorder within, forges an alliance with another state, entirely for his own security, is a temporary and submissive ally.

An ally who forms an alliance for the sake of alliance and is

ever assisting and amiable, is a constant ally through even dire adversity.

An ally of amicable disposition is a true ally. An ally who has relations with an enemy is an unpronounced ally. An ally with active relations with friend and foe is an ally to both.

An ally with hostile intentions, and friendly to the enemy, is a dangerous ally, whether he is professing assistance, or is competent to give it.

An ally who helps the ally of a hostile state, or any other state with diplomatic relations with the hostile state, is a common ally; an ally, with large and rich territories and is contented, strong and inactive, will be an indifferent ally.

A state which, because of its own weakness, follows the fortunes of allies, and enemies, without rupturing relations with either, is common ally.

A state which neglects an ally in trouble and seeks assistance with or without reason, is callous of its own danger.

Which is better: an immediate small gain or a remote large gain?

The latter is better, provided it springs from productive undertakings and is continuous; otherwise, the former is to be preferred.

Chapter 50

LAND ACQUISITION

A PACT entered into to acquire land is an agreement of peace to acquire territory.

A state which acquires rich and fertile land, under a pact of peace, is the gainer.

Where such land is acquired by invading a hostile power the state is a double gainer: it gains territory, and also victory over a powerful enemy. There is facility in obtaining land from the weak: but the land so obtained is bound to be poor, and create a breach of alliance with a neighbouring ally.

Where two coordinate powers operate to acquire land, the one

which gains land by subduing a fortified enemy, obtains an advantage over the other: for it can protect the acquired land.

Where land is acquired from an enemy, it is better to obtain it from a debilitated enemy; for land, adjoining an established state, must be vigilantly guarded at great expense.

One must acquire a small piece of land which is contiguous to a larger unit which is distant, and which is self-maintaining, than that which has to be protected with arms.

Of two states with land and river fortifications, acquisition of land from the former is better, as it is easier to reduce land fortifications than water fortifications. And the latter is much easier to reduce than mountain fortifications.

Chapter 51

PACT FOR COLONISATION

A PACT for colonisation of waste land is a continuous pact.

A state colonising fertile land is a gainer over another state. A limited area, with irrigation facilities, is better for colonisation than a vast plain. Among plains, that tract which can stand both late and early crops with less labour, and taking less rains for cultivation, is to be preferred to watered lands, lands suitable for grain cultivation is to be chosen, in preference to lands suitable for other crops.

Where the area is vast and well watered and is suitable for crops other than foodgrains, it should be colonised first, since it yields not only to farming, but also to fortification. Soil fertility is essentially cultured and artificial.

Though fertile land enriches the exchequer and the store house, mines are to be preferred if they are of precious metals, as they would enrich the treasury and enable further acquisition of resources.

It is always better to colonise sparsely populated land, while land with heavy population creates problems of government. Colonisation should always be attempted with primary section of the population, as such colonisation is likely to be plentiful,

permanent and professionally diversified.

One should always attempt to colonise virgin land, as it can be put into several types of utilisation like agriculture, pasture, manufacturing goods, credit transactions and creation of riches, attractive to merchants. Colonisation of densely populated area offers advantages, in that it is a state within a state. When a state desires to retrieve land, mandated for colonisation to another, the party chosen should be saplers, of low ancestry, of low spirit, dependent, addicted to weaknesses, fatalistic and irresolute in action. When colonisation becomes costly in men and resources, a man of low ancestry will perish in consequence of his losses in men and resources. His strength will be sapped and can be easily subdued. Nor can a coloniser of weak character pretend to hold a colony under his sway long, or secure against an attack. The same is true of a person addicted to evil habits. A fatalist never endeavours to develop a strong colony. So too an irresolute coloniser, who becomes a prey to any concerted attack. A state employing such colonisers would always be sure of its own hold on the colony.

When a major state constrains another to sell a position of its territory, the latter may make a pact and part with its fertile tracts. This is called "exposed peace."

When a state of coordinate status demands territory from another for a consideration, the latter may part with it, after carefully considering if the territory can be recovered at a later date; if any enemy can be subdued by creating the buffer tract, or if the sale would enable it to get new allies, or assistance for developmental work.

Whichever state thus acquires new allies, new territories or new resources, will obtain a distinct advantage over others.

Chapter 52
PACTS FOR CONSTRUCTION AND DEVELOPMENTS

WHEN a state makes a pact with another for the construction or development of any work like a "fortress" the pact is called a

pact for project.

When a state constructs an impregnable fortification with the least expenditure of labour and resources, it has an advantage over the other.

Among fortifications, land, riverine and mountainous, the last is the best. Among irrigated works, that with perennial flow is better than those with other water sources and among perennial irrigation projects, that which can irrigate a vast fertile plain is the most valuable.

Among forests, a forest with valuable forest produce and which expands into wild regions and has a river coursing through it, is the most covetable. Among game forests, a forest well stocked with ferocious animals and contiguous to an enemy area is to be coveted.

Among population groups, it is always advantageous to have large demographic groups of mild character than small groups of ferocious nature. When population is large, they can be employed in diverse occupations, both in the battle-field and in the camp. They can also be trained for combat and discipline.

Among mines, those which can be exploited with least expenditure of resources, yielding valuable products and commanding easy communications, are the best. Mines yielding inferior products are not to be neglected, if their products are easily marketable.

Among trade-routes, waterways are prone to be obstructed and strategically more vulnerable than land-routes. Of waterways, those near the shore are to be preferred to those in mid-ocean, as they touch many trading stations *en route*. Among waterways, riverways are preferable to ocean routes.

Among land-routes, highways in the plains are preferable to roads in the hills. Of highways, those which pass through mines, populated areas, and can transport merchandise are to be developed in preference to others.

It is always wise to undertake work which would help consolidation of the state rather than works which would benefit hostile interests. Where the advantages are balanced, the position should be diagnosed as of stagnation.

One should always avoid works which involve more outlay and

yield less output. Where outlay and output balance, the position is stagnant.

It is always wise to select such works for construction and development as involve least outlay and yield the greatest profit and resources for strengthening the state.

Chapter 53

STRATEGY FOR A REAR ENEMY

WHEN an invading state and its enemy manoeuvre to capture their respective enemies in the rear, the state which successfully operates to get greater resources from its enemy gets an advantage over the other. Resources are an additional strength to a state.

Resources being the same, the state which captures the rear of a force, with vast preparations, gains an advantage; since such a force has to quel the enemy in front, before attacking the one in its rear. Where resources are limited, the state can be subdued by the allied states.

The state which attacks the rear of a state engaged in a total war gains more advantages, since its base is usually undefended and, therefore, can be easily reduced to submission.

Forces being balanced, it is always better to attack an enemy pursuing a fleeing army than one engaged in trench operations. It is easier for an entrenched enemy to launch a counter-attack and the state attempting the attack may get sandwiched between its entrenched enemy and the enemy attacking its own rear.

A state which attacks the rear of a force engaged in an offensive against a virtuous state has an advantage since the moral opinion of other states, and of its own public, will be on the side of the state.

When two states are engaged in combat, one with an ally and the other with a hostile state, the state attacking an enemy is at an advantage, for the former may make pact with the ally and counter-attack while the latter cannot easily disentangle itself from its engagement with the enemy.

When two states are engaged in combat one with an ally and

the other with an enemy, the state which attacks the rear of the former is at an advantage; for, the state engaged with an enemy will have the support of its own allies and can successfully out-manoeuvre a rear attack, while no ally will help a state out to destroy its own side.

When the invading state and its enemy seek to exact exhorbitant reparations from an enemy, the state whose enemy has suffered considerable loss of resources and men gains advantages.

States capable of harming the rear of an enemy are of three categories: the states stationed behind the enemy and the states situated on the two flanks of the enemy.

A state situated between an invader and his enemy can be said to be a buffer between two states. When such a state has strong fortifications and other defensive resources, it becomes a powerful impediment in attacking operations. When the invader and his enemy both combine to subdue a buffer state by harassing its rear and manoeuvre to break the alliance of the buffer state with another by intaking it, the state which first wins a new ally in this manoeuvre gains an advantage. An enemy constrained to sue for peace is of greater value than an ally compelled to sustain an abandoned alliance.

Among offensives mounted in the rear, or in the front, an offensive on diplomatic bases is the best. An open war will inflict heavy losses on both sides in men and resources, so that even the victorious are like the defeated in the losses of men and resources, which they suffer. It is better to destroy an enemy completely even at heavy loss of men and resources.

When an invader is encircled by an enemy in the rear, and the invaded enemy in front, and another enemy, he should pursue the following policy:

The rear enemy will usually lead the invaders' frontal enemy to attack the invaders' friends and will provoke the enemy of the rear enemy against the ally of the rear enemy.

The invader having provoked war between them should neutralise the rear enemy's manoeuvres. He should provoke operations between the allies of the enemy of the rear enemy and the allies of the rear enemy himself.

The invader should also keep his frontal enemy's friend engag-

ed in combat with his own ally. And with the help of the ally of his ally, he should evade the attack of the ally of his enemy's ally.

The invader, with his ally's assistance, should hold his rear enemy at bay and with the assistance of ally's ally prevent his rear enemy attacking the enemy of his rear enemy.

The invader should thus bring into the front the circle of alliance of which he is a member, and debilitate his enemies, keeping his counsels secret and sustaining his alliance inviolate.

Chapter 54
RESTORATION OF LOST BALANCE OF POWER

WHEN an invader is assailed by an alliance of his enemies, he should try to purchase the leader of the alliance with offers of gold and his own alliance and by diplomatic camouflage of threat of treachery from the alliance of powers. He should instigate the leader of the allied enemies to break up his alliance.

The invader should also attempt to break the allied enemies' formation by setting up the leader of the alliance against the weaker of his enemies, or attempt to forge a combination of the weaker allies against their leader. He may also form a pact with the leader through intrigue, or offer of resources. When the confederation is shattered, he may form alliance with any of his former enemies.

If the allied enemies have no leader, the invader can form a pact with the most influential member of the confederated allies. Or with a powerful member, or with a popular member or with a designing member or with a transient ally, bent on protecting and advancing his own self-interest.

If a state is weak in treasury, or in striking power, attention should be directed to strengthen both through stabilisation of authority. Irrigational projects are a source of agricultural prosperity. Good highways should be constructed to facilitate movements of armed might and merchandise. Mines should be developed as they supply ammunition. Forests should be conserved as they supply material for defence, communication and vehicles. Pasture lands are the source of cattle wealth.

Thus, a state should build up its striking power through development of the exchequer, the army and wise counsel; and, till the proper time, should conduct itself as a weak power towards its neighbours, to evade conflict or envy from enemy or allied states. If the state is deficient in resources, it should acquire them from related or allied states. It should attract to itself capable men from corporations, from wild and ferocious tribes, foreigners, and organise espionage as will damage hostile powers.

Chapter 55

PACT WITH POWERFUL ENEMIES

WHEN a minor state is invaded by a major power, the former should seek protection from a state more powerful than the invader, and who is not influenced by it. If coordinate states attack each other, protection should be sought from states with greater stability or diplomatic acumen.

In case no power superior to the invader is accessible, the minor state should form alliance with its coordinate states who cannot be influenced by the invader's money, army or diplomatic manoeuvres. Among such states, alliance should be with those who can evince dexterity in strategic preparations.

In case no such coordinate states are accessible, the minor state should forge alliance with other smaller states whose integrity is unassailable and who can oppose the invader. Of such states, preference should be given to the one with favourable battle-fields; of such, greater preference should be accorded to those with ready preparations for strategic action. Of such, to those which possess armaments for action.

In case no such opportunity is available, the state attacked should retire into a strong fortification, which it can hold against the attack of the invader; and where the home supply lines cannot be breached by the invader. Where such fortifications are many, preference should be given to fortifications where supplies can be ensured.

Having entrenched itself behind strong fortifications, it should endeavour to oppose the invader with the assistance of an ally,

or buffer state, or neutral power, by devastating the invader's territory. It should mobilise favourable interests in the invader's camp and disintegrate the loyalty of the attacking forces. It should organise action to spread disaster in the invader's camp by weapons, fire and poison and inflict heavy losses in men and resources on him. It should manoeuvre to break the invader's alliances by intrigues. It should cut off the supply lines of the invader. It should feign truce and attack the invader at opportune moment. It should break the invader's morale and compel him to make pact of surrender. It should increase its defensive power by collecting the armies of its allies and by protecting the collected armies behind strong fortifications. It should organise guerilla operations to harass and fight the invader from valleys, pits and at night and dismantle the invader's work. This will make the invader's operations costly in men and resources. The invader should be compelled to arrive for operations in distress and disease.

In the absence of such circumstances, or when the invader's army is very powerful, the state attacked should retreat speedily from its fortifications. The state then should sue for peace with the invader, or make approach to it through an ally, and place its resources at the disposal of the invader.

Sheltered under the protection of the invader, the state should serve the major power like a vassal. Fortifications, fresh acquisitions, celebrations of state, trade and commerce, sports—should all be organised only with the permission of the invader. All internal transactions and extraditions actions should be undertaken with the invader's approval. It should regulate its relations with its allies so as not to affect the invader as much as possible. It should observe all decorum imposed on a conquered power, in fair combat.

Chapter 56
PACTS AND BREACH OF PACTS

THE words "peace", "pact of peace" and "armistice" are synonymous. They spring from mutual faith among states.

Rulers in the past made pact by swearing by fire, water, plough, fortwall, gold and other articles considered sacred. Often saints and venerable persons were admitted to function as securities to a pact. It is always better to have as security a person capable of influencing the enemy.

A state with ascending power may break a peace pact.

Chapter 57

BUFFER STATES, NEUTRAL STATES AND CONFEDERATION OF STATES

THE third, and the fifth states from a buffer state can be said to be friendly to it, while the second, the fourth and the sixth can be said to be generally unfriendly. If a buffer state is friendly to all these states, the invader should be friendly to it, if not, the invader should form alliance with these states.

If the confederation of states is in favour of the invader, the invader can liquidate the buffer state; if not, the invader should mount a diplomatic offensive, by inciting states inimical to the buffer state and thus strengthen his own position and quel the buffer state.

Where such a manoeuvre is not possible, the invader should seek alliance with an enemy of the buffer state, or incite rebellion against it. If that is not possible, reconciliation with the buffer state is the only way out of the situation. If the buffer state manoeuvres to seek alliance with an enemy of the invader, the invader should forestall the movement by offering help to the third state in the form of resources and army.

If the buffer state moves to involve a neutral power, the invader should break the alliance between them. Whichever state, among the buffer states and neutral states, has greater influence with the confederated states should be appeased by the invader.

Those likely to be friendly to the invader with homogeneous interest are, a power which marches with the invader with a divergent end in view; a temporary ally marching against an

enemy; an ally in a pact of peace with the invader; a power marching for his own interest; a power combining for operations with others; a mercenary power transacting in its army and treasure and one pursuing twofold policy.

States which are likely to be subservient to the invader are a contiguous state expecting an attack from a major power; a buffer state between the invader and his hostile power; the enemy in the rear of the powerful state; a state capitulating to the invader; a minor power scared into submission; a power vanquished by the invader; and powers contiguous to the enemies of the invader.

The invader should form alliance with powers with the same policy, and attempt to subdue an enemy.

If the invader finds an ally, growing in power and likely to grow in strength, he should engineer breach of peace against the ally.

The invader may also create a situation in which his ally would be constantly needing his aid.

The invader should withdraw aid from an ally, should he be disintegrating : he should neither allow an ally to grow in power nor let him deteriorate.

Should an ally of the invader have relations with an enemy of the invader, he should attempt to break the alliance and destroy both the ally and the enemy.

Should an ally attempt to remain neutral, the invader should instigate situations which break the peace between the ally and his neighbours, and offer the ally aid.

A state should exercise incessant vigilance in observing the situation of advance, recession, stagnation, reduction and ruin of the other states and adjust its strategic manoeuvres.

Book IV

STATE IN CRISIS

Chapter 58

PERVERSITIES AND FOIBLES

WHEN disasters assail at once, one should ponder what course one should take: offensive or defensive. Disasters arise either from accidents, or from feeble policies. Perversities spring from abandonment of the six-fold state policy, or from enfeeblement of authority, or from disloyalty on the part of either nationals or foreigners, or both; or from love entanglements, or from gambling or other foibles; or from fire, flood, and other eight calamities.

According to one school of thought, distress afflicting the ruler is more important, than ministerial or popular disasters, distress arising from faulty defences, or from financial strains or from army misfortunes.

Another authority elevates ministerial distress above all other kinds of distress, as that affects the entire business of the state and the security of authority.

Kautilya opines that royal distress is the most poignant; since all authority and administration spring from the sovereign. The sovereign is the sum total of the people.

A fourth authority formulates that popular distress is the most serious in a state, since all state resources are dependent on the people.

Kautilya agrees that all authority and administration are concentrated in the ministers, like execution of projects affecting the welfare and security of the people like defence, security, development, the army; and remedies against disasters and therefore ministerial disasters can generate popular disasters.

A fifth authority says that between popular distress and distress created by faulty defences, the latter is the greater evil, as it affects security.

Kautilya would consider popular distress as the greater evil, since the very life of the state depends upon the people like, for instance, construction, trade, farming, cattle-conservation, coinage, stability, integrity and opulence.

A sixth authority would magnify financial distress among others. Since financial consideration would affect fortifications, diplomacy, alliances and armed might of the state. Finances can more easily be secured, or defended, than fortifications.

Kautilya would prefer fortifications to finance. Finances are secured by fortifications. A well-defended state can not only secure its finances, but also maintain successful diplomacy, control loyalties and alliances, maintain powerful armies and secure the frontier relations. Defences mean high security for the state.

An eighth authority prefers a strong army to strong finances. An efficient army might prevent damage to alliances, foreign relations, financial stability and administrative tranquillity.

Kautilya observes that finances are the foundation of armed might. With weak finances, revolutions may be incited, and the army itself may revolt against authority. Due to environmental transformation, either finance or armed might may become the superior power, but ultimately finances alone can secure armed might. Since all state functions are dependent on finances, financial distress is the more serious.

A ninth authority gives greater emphasis to the distress of an ally over distress of the army. He argues the great utility of an ally warding off an enemy; but also in coming to the assistance of the state with finance, army and lands in times of strain.

Kautilya prefers a powerful army. Armed might keeps alliances and ensures the respect of the enemy. In times of strain, no friend or ally can be fully trusted.

When authority gets weakened in a state, the extent, affection and power of the uninfected part, can help in restoring strength to authority.

When two sectors of sovereignty are infected with weakness, they should be carefully considered along with other aspects of sovereignty and strengthened.

When the distress in one sector of the state tends to infect the other sectors, those distresses should be deemed serious, and, properly remedied.

Chapter 59
AFFLICTIONS OF THE RULER AND OF THE STATE

THE ruler is the natural essence of the state.

The afflictions of the ruler may be either inherent or extraneous. Inherent afflictions are more serious than extraneous ones. Afflictions arising from a minister are more sinister than other kinds of inherent afflictions. The ruler, therefore, should exercise control over finance and the army.

Of dyarchy and foreign rule, the former perishes because of jealousy, favouritism and scramble for domination. Kautilya says that foreign rule can be disastrous in that the foreign ruler can have no identity of interest with the conquered people, denudes it of its resources, or treats it like commercial chattel. When the country refrains from loving him, he retreats and abandons the country.

Who is better: a blind ruler or ruler who flouts wisdom?

Kautilya prefers a blind ruler since he can be influenced by counsel; but a ruler who flouts wisdom brings ruin on himself and the state.

Who is better: a disabled ruler or an inexperienced ruler?

Kautilya observes that a disabled ruler respects his usual duties; but an inexperienced ruler does as he pleases. There are several kinds of disabilities of rulers: moral disability, physical disability. Among inexperienced rulers also there are several kinds: a noble blooded ruler and a base-born ruler.

Who is better: a weak but noble-born ruler or a powerful but low-born ruler?

People naturally respect noble ancestry, though the ruler may be weak. A prosperous people, therefore, inevitably prefers a noble, though weak, ruler. Virtue makes for friendship.

Chapter 60
COMMON AFFLICTIONS

IGNORANCE and indiscipline are the cause of men's afflictions.

An inexperienced man does not understand the damages arising from vices.

Vices arising from anger are three-fold and those springing from rapaciousness are four-fold. The worse of the two is anger. Anger and rapaciousness have ruined many rulers.

According to one authority, anger is the privilege of a righteous man. From it springs courage : it liquidates the unwanted and keeps people scared; it prevents sin. Similarly desire is necessary for enjoyment of the fruits of one's accomplishments.

Kautilya observes that anger creates a ring of enemies and spreads pain all round. Succumbing to, sensual enticements, generates contempt; and exposes a person to blackmail from swindlers, gamblers, hunters, musicians, actors and others socially undesirable. If anger generates enmity, feebleness, in the face of temptation, spreads contempt. Troubles from enemies are more dangerous than loss of wealth. Similarly, afflictions created by vices are more devastating than association with undesirables. The latter can be shaken off in a moment, while afflictions arising from vices haunt a person for life.

Which is the greater evil : misuse of language or of money or punishment?

One authority opines that misuse of language is the greater evil; since it creates enmity even from a brave person and spreads pain.

Kautilya considers misuse of money, the greater evil; since injury caused by misuse of language can be healed with money, whereas misuse of money causes loss of livelihood. Misuse of money occurs by gifts, exaction, loss or desertion of money.

Of misuse of money, and of punishment, one authority considers the former to be the worse sin since wealth is the foundation of all secular transactions.

Kautilya would consider misuse of punishment as the greater evil, since it creates indignant enemies, and may endanger the life of the punisher himself.

The four-fold vices are: hunting, gambling, women and intemperance.

Authorities differ as to which of these is the greatest vice.

Kautilya considers infatuation of women to be the worst in certain situations and intemperance in others.

Chapter 61

OF DISTURBANCES, IMPEDIMENTS AND FINANCIAL DISTRESS

SEASONAL calamities are fire, flood, plague and fatal epidemics.

Of fire and floods, floods are more devastating. Since they inundate hundreds of villages. Famines dislocate life and livelihood to many. Fatal epidemics afflict common populace. They do not cause national attrition, like the loss of aristocracy of talent and character.

Of disputes among people, and those among rulers, Kautilya considers disputes among rulers to be the more destructive. Popular disputes may be productive of better work for the states. Disputes among rulers are difficult of settlement and dislocate life in the states concerned.

Of rulers addicted to sport, and of people addicted to games, Kautilya says that the damage done by rulers addicted to sport is greater than the damage done by people addicted to them, as popular enthusiasm is short-lived; while ruler's addiction can cause great harm by favouritism, nepotism and holding up of work in factories.

Of impediments caused by boundary officers and traders, the impediments caused by traders are the graver; since they unite to create fluctuations in the prices of goods and live on the profit they can make by exploitation.

Which land is profitable to confiscate: lands of the nobles or grazing land for cattle ? Kautilya prefers grazing lands as they are productive of cattle wealth.

Of robbers and wild tribes, wild tribes cause more destruction as they have leaders, fortifications and armed might; while robbers who rob the people can be more easily apprehended and punished.

Of benefits derived from one's own or a foreign country, bene-

fits derived from one's own country consist of produce, cattle, gold and raw materials and are of great value to the welfare of the people; whereas benefits from a foreign country operate in the reverse direction.

Financial distress is caused by disorders, loss of revenue by remission of taxes; dissipation of resources, falsification of accounts and by resources transferred to a contiguous state or a wild tribe.

To maintain prosperity of the state, troubles should be remedied, causes eliminated, impediments removed and financial distress, avoided.

Chapter　62

DISTRESS OF THE ARMY AND OF THE ALLIES

AFFLICTIONS of the army are : insult to the army; army confusion; non-payment; affliction by disease; arrival after a long march; tiresomeness; suffering heavy losses; suffering defeat; destruction of advance troops; weather-beaten, entrapping in difficult terrain; disappointedness; retreat; housesickness; infested with traitors; mutinying in the major sector; torn by disputes; arrival from foreign state; serving abroad; specialising in limited manoeuvres; suffering from impediments; harassed; interruption of food supplies; cutting off; detained at home; protected by an ally; containing hostile personnel; scourged by rear enemy; loss of communications; loss of training in combat.

Insulted and confused army can be put to the field after being honoured and rewarded.

The unpaid army can be engaged after payment.

The freshly arrived army can be refreshed and put to the field. The tired army can be revitalised but not an army suffering from loss of leaders.

A repelled army can be re-staffed and put to the field. Traitorous army must be abandoned. Homesickness can be cured, but

not fear of enemies. Provoked army may be pacified. A trained army can be reconstructed, but not an untrained one.

Elimination of vices and afflictions, recruitment of fresh personnel, avoidance of enemy's ambush, concord among army leaders are means of strengthening of the army.

The army should be protected from the enemy's machinations; and antidotes against afflictions of the army should be quickly devised.

The following allies are difficult to acquire and retain:

An ally who, under another's influence, has marched against another ally.

An ally, who can be easily purchased.

An ally, with an undecisive policy, who marches against another ally.

A fickle ally who is surrounded and hastily retreats.

A dissatisfied ally who is made to pay much or receives less.

An ally, under duress or compulsion, or who seeks fresh alliances, having broken old alliances.

An ally incapable of retaining friendly relations.

An ally who appreciates his duties and responsibility and is honourable, is scared of the destruction of another friend, or, is apprehensive of danger from combination of hostile powers, or is influenced by conspirators.

One should avoid causes which damage alliances and pursue a path of firm friendship among states.

The above indicate the wisdom and the weapon gathered by Kautilya for purposes of world conquest and world conservation.

INDEX

INDEX

ACCOUNTS : Registers of, 84; year of, 84; penalties for wrong, 85, 87; submission of, 85 ; annual statement of, 86; embezzlement of, 86-88

Administration : significance of, 11; qualities in, 12; evaluation of qualities in, 12-13, 90; deliberation in, 16; planning of, 24-25; director of Departments in, 26-27; qualities of personnel, 53, 89; ruler in, 53-54; fidelity of, 54, 55, 90

Advisers : their qualifications, 51-52; selection of, 52; spiritual, 53

Allies : acquisition of, 125 ; kinds of, 125-6; strategy for, 126-7

Ambassadors : their selection (*vide* diplomacy), 16-17

Arthasastra : its origin, 1-2; early propagation of, 3-4; and culture, 6-8

Authority : in the State, 48-49 ; punishment and, 49; anarchy and, 49

BIFORMAL RELATIONS, 122-123; states in, 122

CATTLE : Controller of, 102; classification of, 102; management of, 102-103

City Administration, 33; chief of, 103; inspection, of 103; rest houses, 103; fire control in, 104; curfew, 104; guards in, 105; jails and, 105

Collectors of revenues, 25

Councils : deliberations, secrecy of, 16, 61-62; composition of, 16, 62, 63; administrative, 61

Courtesans, 32-33; Controller of, 99 ; understudy for chief, 99; property of, 99-100; clients for, 100

Crisis : financial, 141-142, 145; army, 42, 146, 147; common, 146-147; state, 36; popular, 36-37

DEVELOPMENT : strategy for, 129-130 ; forest, 130-131; land routes, 130 ; mineral, 130-131

Diplomacy : selection of personnel, 16-17, 63 ; planning of, 33-34; war and peace, 35-36; ambassadors, 63-64; business of, 64-65; manoeuvres of, 115-116; alliance and, 116; pacts and, 121

Director : of Stores, 27-28, 91-92; of Trade, 28-29, 92-93; of Textiles, 29-30, 96; of Farming, 30; of Tariffs, 93-95

EDUCATION : in Monocyclical planning, 8-10; schemes of, 9-11, 50; discipline and, 49-50; control and, 50-51

Espionage : functions of, 13; personnel, 13-14, 55-58; objectives of, 14-15; parties and, 58-59; bars and, 98

Exchequer : administration of, 21-22, 26

FARMING : Director of, 97; labourers in, 97-98

Forests : principal types, 23

Forts : types of, 23; plans of, 78;